$2.00

California Painters: *New Work*

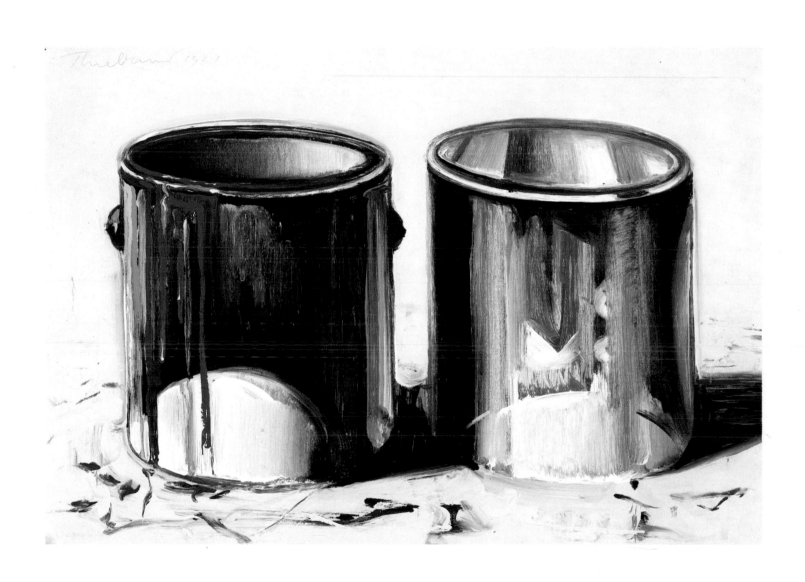

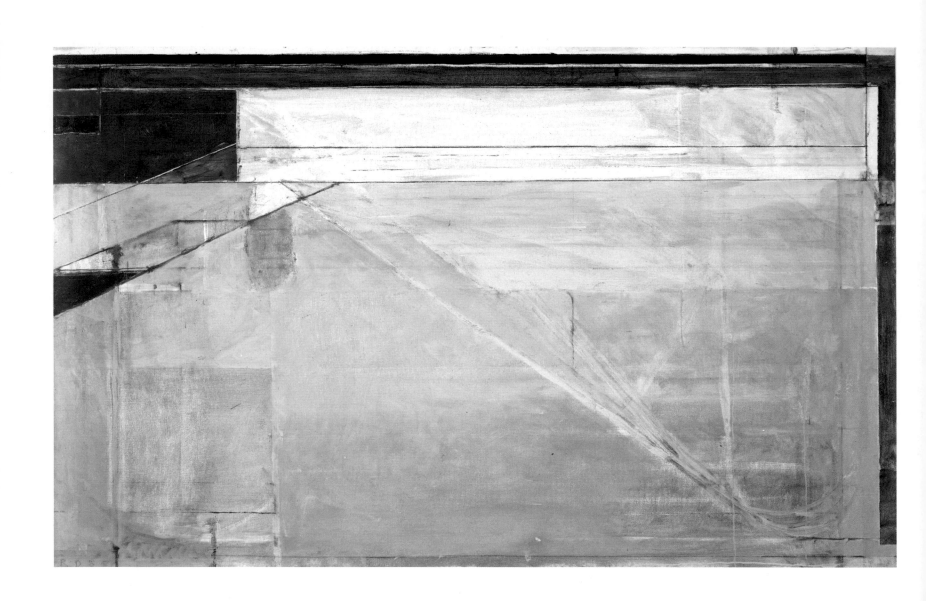

California Painters:
New Work

Henry T. Hopkins

Portraits by
Jim McHugh

Chronicle Books
San Francisco

California Painters: New Work was produced by
Ed Marquand Book Design, Seattle
Edited by John Pierce
Typeset by Continental Typographics, Los Angeles
Film processing by A & I Color Labs, Los Angeles

For dimensions, height precedes width precedes depth.

Cover: David Hockney, *Montcalm Interior with Two Dogs*, 1988, oil on canvas,
72 x 60 in. © David Hockney

Half-title: Wayne Thiebaud, *Two Gallon Cans*, 1988, oil on paper, 18 x 22 in.

Frontispiece: Richard Diebenkorn, *Ocean Park #132*, 1985, oil on canvas,
48 x 78 in.

Back cover: (clockwise from upper left): Mary Corse, David Hockney, Joan
Brown, and Robert Colescott

Library of Congress Cataloging-in-Publication Data

Hopkins, Henry, 1928–
 California painters.

 1. Painting, American—California. 2. Painting,
Modern—20th century—California. I. McHugh, Jim,
1948– . II. Title.
ND230.C3H67 1989 759.194 89-7102
ISBN 0-87701-601-1
ISBN 0-87701-593-7 (pbk.)

Printed in Japan

Distributed in Canada by Raincoast Books, 112 East 3rd Avenue, Vancouver,
B.C. V5T 1C8

10 9 8 7 6 5 4 3 2 1

Photo credits: D. James Dee: 88–90; Susan Einstein: 53, 58 (top and
bottom), 92, 93; M. Lee Fatherree: 26, 28 (bottom), 36, 37 (top), 48, 49 (top
and bottom), 63, 64 (top and bottom), 81–84, 78 (top and bottom), 79, 80,
103–105, 139, 140 (top and bottom); Keith Fitzgerald: 42, 43 (top and
bottom); Brian Forrest: 8, 19, 20 (top and bottom), 24, 25 (top and bottom),
57, 132–34; Paul Hester: 86, 87; William Nettles: 30, 97–99; Douglas M.
Parker Studio: 6, 65, 67, 108–110, 118 (top and bottom), 120; Paul Ruscha:
111, 112, 113 (top and bottom); Richard Schmidt/Photographics: 75;
Schopplein Studio, San Francisco: 32, 34 (top and bottom); Jim Strong: 37
(bottom); Tom Vinetz: 29; Zindman/Fremont: 61 (bottom)

Elmer Bischoff's statement from "Walking a Tightrope," by Jan Butterfield, in
Elmer Bischoff, 1947–1985. Copyright © 1985 by Laguna Art Museum.
Reprinted by permission of the Laguna Art Museum, Laguna Beach,
California.

Robert Colescott's statement from "Interview With Robert Colescott," by
Katherine Weiss, in *The Eye of the Beholder: Recent Work by Robert
Colescott*. Copyright © 1988 by University of Richmond. Reprinted by permis-
sion of Marsh Gallery, Modlin Fine Arts Center, University of Richmond,
Virginia.

Roy De Forest's statement from *Roy De Forest: Retrospective*. Copyright
© 1974 by San Francisco Museum of Modern Art. Reprinted by permission of
San Francisco Museum of Modern Art.

Richard Diebenkorn's statement from "Almost Free of the Mirror," by Dan
Hofstadter. Copyright © 1987 by Dan Hofstadter. Originally in *The New
Yorker*.

Sam Francis's statement from *Sam Francis: Paintings on Paper and Mono-
types*. Copyright © 1983 The Art Museum Association of America. Reprinted
by permission of the American Federation of Arts.

David Hockney's statement from "A Visit with David and Stanley Hollywood
Hills 1987," by Lawrence Weschler, in *David Hockney: A Retrospective*. Copy-
right © 1988 by Museum Associates, Los Angeles County Museum of Art.
Reprinted by permission of Museum Associates, Los Angeles County Museum
of Art.

Wayne Thiebaud's statement from *Art of the Real: Nine American Figurative
Painters*, ed. Mark Strand. Copyright © 1983 by Clarkson N. Potter, Inc.
Reprinted by permission of The Crown Publishing Group.

Chronicle Books
275 Fifth Street
San Francisco, California 94103

Contents

Preface 7

Introduction 9

Lita Albuquerque 16

Peter Alexander 19

Carlos Almaraz 21

Billy Al Bengston 24

Elmer Bischoff 26

William Brice 29

Christopher Brown 32

Joan Brown 35

Hans Burkhardt 38

Robert Colescott 41

Mary Corse 44

Roy De Forest 47

Richard Diebenkorn 50

Llyn Foulkes 53

Sam Francis 56

Charles Garabedian 59

Rupert Garcia 62

Jill Giegerich 65

Joe Goode 68

Roger Herman 70

David Hockney 74

Robert Hudson 77

Oliver Jackson 81

Richard Jackson 85

Jess 88

Craig Kauffman 91

Helen Lundeberg 94

Ed Moses 97

Lee Mullican 100

Nathan Oliveira 103

Gordon Onslow Ford 106

Frank Romero 108

Edward Ruscha 111

Raymond Saunders 114

Alexis Smith 117

Mark Tansey 121

Masami Teraoka 124

Wayne Thiebaud 128

Joyce Treiman 131

Emerson Woelffer 135

Paul Wonner 138

Acknowledgments 141

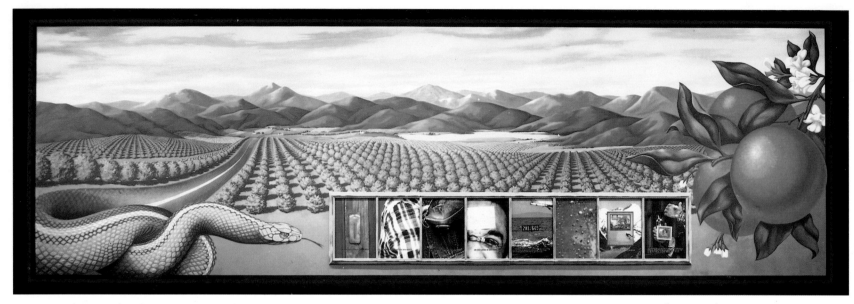

Alexis Smith
Same Old Paradise, 1987
Mixed-media installation
20 x 60 feet

Preface

It is my belief that the work of contemporary artists should be presented to a wider audience, and it is this belief alone that leads me to select, from among the hundreds of recognized artists living and working in California, forty-one painters for inclusion in *California Painters: New Work*.

I admit that my real and philosophical age has influenced my selection. I continue to admire the "old-timers" who chose to be in California long before there was a climate for acceptance. I watched John McLaughlin, Lorser Feitelson, Oskar Fischinger, and Peter Krasnow live and die without any real knowledge of the importance of their art in a national and historical context. Choosing a number of these heroes who are still living—Hans Burkhardt, Gordon Onslow Ford, Emerson Woelffer—precluded the selection of younger painters for whom I have high regard, such as Ciel Bergman, Squeak Carnwath, Karen Carson, Tim Ebner, Mike Kelley, Jim Morphesis, Margaret Nielsen, and Michael Wingo.

I have attempted to recognize, with a few examples, the growth and acceptance of painters from minority cultures who might have been ignored a decade ago. I chose not to invade the area of realism except to note it with the work of elders Wayne Thiebaud and Paul Wonner; there are so many excellent practitioners that they demand a book unto themselves.

My biggest dilemma was deciding where painting ends and another medium begins. My inclusion of Lita Albuquerque, Jill Giegerich, and Alexis Smith and my exclusion of Charles Arnoldi, Laddie John Dill, and Betye Saar are certainly open to question, but my familiarity with these artists causes me to think of Saar as an object maker and Arnoldi and Dill, increasingly, as sculptors.

In addition to the challenge of selecting the artists, I was enticed by the format of the book, which calls for each of the painters to be represented by more than one of their recent works. Almost all of the illustrated artworks have been created since 1984. This format provides some depth and increases our understanding of the most current trends in painting.

Jim McHugh's excellent and insightful photographic portraits and the statements by the artists help us to engage their personalities and to better understand the creative process. A few artists chose not to make statements, preferring to let their art speak for itself.

Here, then, are forty-one excellent artists; I hope that only a little time passes before another book appears with forty-one more.

Henry T. Hopkins, Director
Frederick R. Weisman Art Foundation
Los Angeles

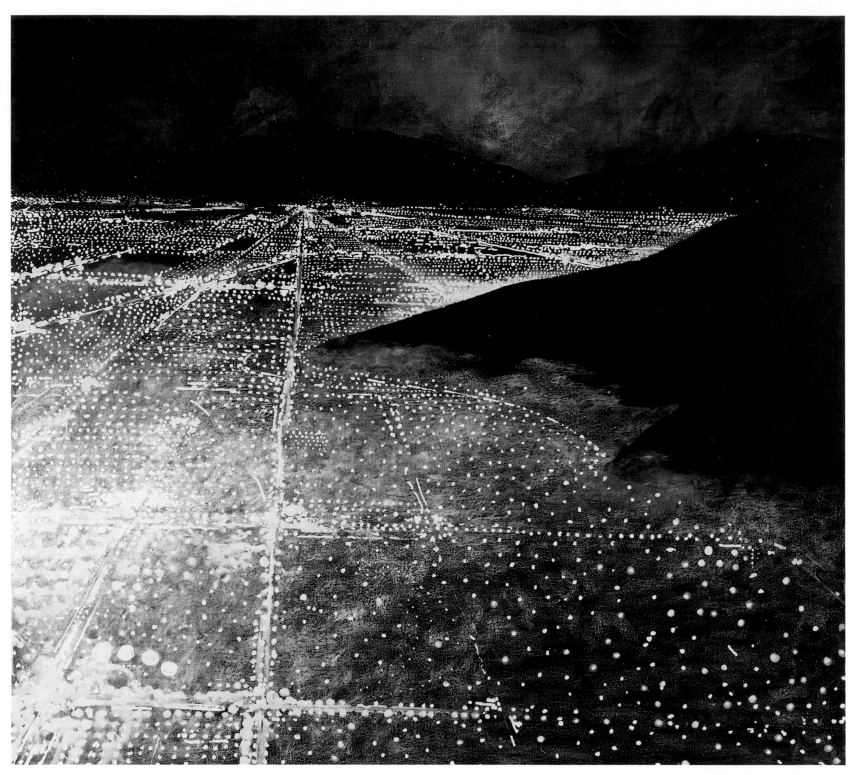

Peter Alexander
Van Nuys, 1987
Acrylic and oil on canvas
60 x 66 in.

Introduction

California Painters: New Work features forty-one California artists. The book serves as evidence not only of the continued and accelerated growth of California's creative community but of its excellence and independence. California is today the sixth largest economic power in the world, the result of a dramatic demographic shift from the East to the West Coast that was fueled by a changing economic and social climate and enhanced by the emergence of the Pacific Rim as a dominant player in international commerce. California's growth affected the state's culture, as its new wealth created art collectors and patrons who supported museums, symphonies, dance, and opera, and who provided financial backing for art galleries. At the beginning of the 1980s California appeared to have taken the first vital step toward achieving parity with New York as an international art center.

The fact that *California Painters: New Work* deals only with painting, and not with sculpture, photography, graphics, conceptual or performance art, video, design, architecture, or crafts—each of which demands a comparable volume—indicates the rapid quantitative advance in the number of artists working in the state in the past decade. With this almost overwhelming expansion in mind, it seems appropriate to provide a modest historical vantage from which to view some of the many currents that now make up the California art scene.

One often-asked question is whether or not California art can be characterized as distinct from the art of New York. I believe that it was possible, until as recently as the 1970s, to define the particular qualities of California art, and moreover, it was possible to differentiate between the art of Southern California and the art produced in the San Francisco Bay Area.

In Los Angeles special characteristics were in evidence as early as the 1930s, when artists such as Stanton Macdonald-Wright, Oskar Fischinger, and Peter Krasnow emerged. As nonobjective painters in the mold of Wassily Kandinsky and Piet Mondrian, they believed in the capacity of line, shape, and color to carry universal messages.

Macdonald-Wright had as early as 1912 achieved a degree of international notoriety for his role, along with Morgan Russell, in founding synchromism, a sophisticated form of cubism that used color rather than shadow to suggest three-dimensional form. When Macdonald-Wright returned to Los Angeles from Paris after World War I, he brought his theories with him, and he became the leading force in what was one of the most advanced aesthetics in the country at the time.

In Los Angeles Macdonald-Wright met European expatriots Peter Krasnow, who developed a series of flat, colorful geometric paintings, and Oskar Fischinger, a pioneer in hand-drawn,

nonobjective film animation. Fischinger had been brought to Los Angeles by Walt Disney to create an abstract sequence for *Fantasia* which ended up on the editing room floor, but he stayed on to experiment with transparent, three-dimensional painting.

Another European-trained American artist, Lorser Feitelson, picked up the modernist thread in the 1930s when he moved to the West. He joined forces with Helen Lundeberg to invent a smooth-surfaced, symbolist style of painting that they called postsurrealism.

But as important as the contributions of these avant-garde artists were to the art of California and of the country, their work was little discussed, even in the art journals of the day, because it went against the tide of national interest in the regionalism of depression-era artists such as Thomas Hart Benton and Grant Wood.

By the early 1950s Feitelson's art had evolved to a large, clear, hard-edged abstraction, a style in which he was joined by John McLaughlin, Karl Benjamin, and Fred Hammersley. This school, called "abstract classicism" by local art critic Jules Langsner, in its turn inspired a number of rebellious young artists to keep the modernist fires burning. Craig Kauffman, Billy Al Bengston, Ed Moses, Robert Irwin, Larry Bell, and, later, Fred Eversley, DeWain Valentine, and Peter Alexander all reached for the clear, clean look. These artists explored new scale, techniques, and materials, such as automotive lacquers, plastics, acrylic, glass, spray paint, and vacuum-formation. Their unusual sensitivity to surface caused critic John Coplans to call them the "fetish finish" school.

The classic abstract imagery used by this group of artists, also known as the "cool" school, was calculated to refute not only abstract expressionism, then nationally dominant, but the locally popular work of artist Rico Lebrun, who had gained acclaim after World War II for his romantic, expressionistic canvases. Despite the artists who rebelled against him, Lebrun left his own legacy. His work infused the developing art of William Brice, Joyce Treiman, and, later, Charles Garabedian, among others.

At the same time, even though the cool school held the high ground, other personalized forms of abstraction appeared. John Altoon produced remarkable works in the tradition of Arshile Gorky, and he became a folk hero to younger Los Angeles artists who were attracted by his ribald and generously encompassing lifestyle and his absolute compulsion to paint. Hans Burkhardt and Emerson Woelffer developed their art in New York and brought an awareness of then-current abstract organic surrealism with them to Los Angeles. Lee Mullican cofounded with Gordon Onslow Ford and Wolfgang Paalen the short-lived school of Dynaton—a branch of

surrealism. He later introduced personalized visions of the signs, symbols, and techniques of primitive cultures into his canvases.

Sam Francis began his painting career in Northern California, and then worked in France, Switzerland, and Japan before he returned to Los Angeles with his worldly and sophisticated color sensibilities. More recently, Richard Jackson has explored a unique form of painting that sandwiches traditional abstract expressionist pigmentation between stacks of stretched canvases. And David Hockney, who now calls Los Angeles home, examines the relationship between Western cubism and Chinese scroll painting, filling his work with the high color and light that drew him to Southern California.

The history of Los Angeles art suggests that abstraction—especially cool, smooth, light-filled abstraction—is renewed with each generation. The character of the city evokes thoughts of clear light, low-level architecture, well-manicured lawns, and the glossy perfection of its seaside location. And, although it rarely appears in recognizable form, the essence of the city has been the subject of much of its art. This phenomenon is most clearly manifested in the work of Robert Irwin, James Turrell, Douglas Wheeler, Maria Nordman, and others, who in the mid-1960s shifted completely away from traditional painting and sculpture and out into the environment. This phenomenon, known as the light and space movement, is of considerable historical importance and is yet to be fully documented.

Even now, the vestigial remains of the cool school can be seen in the work of Lita Albuquerque, Mary Corse, and Jill Giegerich. But the major influences on the artists of the 1970s and 1980s have emerged from a much broader spectrum of concerns. As Los Angeles has continued its rapid physical escalation, it has become less idyllic, and big city concerns have replaced intellectual remove. Social and political activism, the feminist revolution, the issues of minorities, a deteriorating environment, and internationalism have become the major influences on its art. The paintings of Carlos Almaraz, Roger Herman, Frank Romero, and Masami Teraoka echo these thoughts. Los Angeles art of the 1970s and 1980s has become less identifiable as a regional style, and today the artists of the area participate and sometimes lead in every international movement, from appropriation to neo-geo, from conceptualism to neo-expressionism.

Painting movements in the San Francisco Bay Area have developed along more academic lines, with roots deep in the tradition of nineteenth-century American landscape. The rugged beauty of the north coast, Yosemite Valley, and the redwood forests provided Albert Bierstadt and Thomas Hill with endless subjects, which were

admired as much in the East as they were in the West.

In the first decades of the twentieth century, when modernist tendencies based on the French impressionists and postimpressionists began to assert themselves, the manner of Bay Area painting began to change, but landscape remained its primary subject. Artists such as Xavier Martinez, Gottardo Piazzoni, C. S. Price, and the Oakland group known as the Society of Six (William Clapp, Bernard von Eichman, August Gay, Selden Gile, Maurice Logan, and Louis Siegriest) adapted the prevailing artistic environment to their individual needs, but generally their work was characterized by dense pigmentation and natural colors. These elements remain as attributes of Northern California art to the present day.

During the 1930s and into the years of World War II, academic art and narrative mural paintings in the tradition of the great Mexican artists Diego Rivera, José Clemente Orozco, and David Alfaro Siqueiros prevailed, as the majority of artists toiled for the federal government with the support of the Roosevelt administration's Federal Arts Project of the Works Progress Administration. But together with this activity, a flurry of interest in organic abstraction evolved through the efforts of the Howard family artists—Charles, Robert, and Robert's wife, Adaline Kent. In Berkeley, where Hans Hofmann

had been brought to teach, a movement toward geometric abstraction developed, and following the war the California School of Fine Arts (now the San Francisco Art Institute), under the leadership of Douglas McAgy, hired nationally recognized abstractionists Clyfford Still, Mark Rothko, and Ad Reinhardt. Although artists such as Hassel Smith, Frank Lobdell, and Jay DeFeo continued the abstract mission, the major influence of these giants was on the high-art principles of their students. Still in particular introduced a strong morality, which emphasized art as a spiritual force, and he professed that neither the art nor the artist should become a pawn to the marketplace.

Inspired by pre–World War II tradition and fueled by existentialism and the beginnings of the beat generation, painters David Park, Elmer Bischoff, and the young Richard Diebenkorn reintroduced figurative art to the San Francisco area. Their depictions of passive individuals existing without spiritual support in lonely environments gave their work a unique vision. Hailed in France as the "School of the Pacific," this new figuration was minimized in New York as a retrogressive retreat from abstraction. Locally, the movement gave birth to a flood of variants that sustains each new generation of area artists even up to the present day, and it continues to give Bay Area art its own regional spirit.

Nathan Oliveira, Paul Wonner, William Theo Brown, and Jerrold Davis amplified the new figurative movement in the 1960s and went on to more independent positions. Joan Brown, Roy De Forest, Robert Colescott, and, later, Oliver Jackson added a zestful immediacy and personal symbolism that broke away from the isolation of the figure to place it in the midst of frenetic activity.

William Wiley, Robert Hudson, and William Allen moved between painting, assemblage, and object making, adding a rustic twist to Marcel Duchamp's urban wit. Raymond Saunders combined characteristics of children's art with a sophisticated surface reminiscent of Robert Rauschenberg and Jasper Johns. Rupert Garcia used the figure in the context of the earlier Mexican masters with intense political intent, crusading for justice and reform. Most recently, Mark Tansey has employed all of history and art history to provide urbane parables for a disoriented world, and Christopher Brown seems intent on looking back to the existential roots of the movement, as his figures and objects move or stand in isolation.

Of course, these examples prove the rule of difference between the art of Southern California and the Bay Area; but there were integrating movements as well. The assemblage movement in California closely paralleled the rise in popularity of the early work of Rauschenberg, Johns,

and Claes Oldenburg in the East. As was the new figurative movement, assemblage was born out of the existential beat era of the 1950s and 1960s. It was generated in the north and the south, as poet and artist Wallace Berman carried the seed between Edward Kienholz and George Herms in Los Angeles and Bruce Conner and Jess Collins in the Bay Area. Each of these artists is now considered a master of the idiom, adapting the litter of society into poignant sociopolitical commentary. Assemblage has been renewed by the current generation: it has become less poignant and more hip in the work of Alexis Smith, and more technocratic in that of Jill Giegerich.

Pop art evolved simultaneously in Europe, New York, and California. Edward Ruscha, Joe Goode, and Llyn Foulkes, early in his career, developed icons of popular culture in Los Angeles, and Wayne Thiebaud and Mel Ramos achieved national notoriety in San Francisco. Each of these artists has gone on to gain wide respect for his art, which has moved well beyond the pop idiom.

This speedy tour of some of the many creative forces in California will, I hope, impress the reader with the fact that for the past sixty years the foremost art of this state has followed no fashion but its own. Because much of California's art has been conceived in opposition to New York movements, it has been perceived by

the East Coast press to be contrary and insular. Quite the opposite is true, however, and new generations of writers and theoreticians, who no longer judge California art as an extension of New York attitudes, are finding much of it to be universally compelling.

In addition to the state's art-making activity, the University of California and the State University of California systems are playing an increasingly important role by expanding their programs and libraries in art history and theory. Now young scholars can develop intellectual curiosity and pursue the research necessary to move the still somewhat glitzy California art environment to a more serious plateau.

Several years ago Henry Seldis, late art critic of the *Los Angeles Times*, accused California of having an "edifice complex"—a lot of new art buildings but with little in them. Happily, at this time, one can make two observations. The first is that collection development in most California museums has been significant. (Although it is premature to suggest, except in a few areas, that California art holdings rival those in New York.) The Norton Simon and the J. Paul Getty museums as well as the Los Angeles County Museum of Art, the Fine Arts Museums of San Francisco, the Asian Art Museum of San Francisco, and the Huntington Library and Art Gallery in San Marino have all added significantly to their historical holdings in Asian, European,

and American art, which gives a foundation to the state's excellent contemporary collections. A serious student can now get a thorough education through contact with original works of art rather than relying on only slides and reproductions, as was once the case. The ballast of art history is beginning to center and stabilize the ship.

The second observation is that museums in California have been more successful in attracting a bright, well-trained, and ambitious group of curators, each of them anxious to excel through the acquisitions and exhibitions he or she originates. Thirty years ago, ninety percent of the exhibition programs in the state's museums were borrowed from other institutions. Today the figure is down to fifty percent, which is about where it should be.

Fortunately the overwhelming emphasis placed during the 1960s and 1970s on temporary exhibitions to stimulate attendance and visual excitement is coming into balance. Enhanced presentations of permanent collections are increasingly justified by the audiences they generate. Even so, the advantage of so much new museum space is that Californians can reasonably expect that exhibitions of quality organized by out-of-state museums will be seen in a California institution, a great privilege for students and others who cannot travel to New York, Europe, or Japan with any regularity.

The world of art commerce has also grown

and achieved a new level of sophistication. The number and quality of galleries, especially in Los Angeles and Santa Monica, has tripled in the last decade. Quite apart from the benefit of allowing the work of more artists to be seen, these new galleries help to broaden the perspective of art viewers. Unfortunately, that perspective is limited almost exclusively to contemporary art, and one longs for the day when dealers of historical artworks will find California to be a satisfactory place for business.

The greatest reward of all the activity in museums and galleries is to recognize how many of the best-known artists in the country, no matter where they may now live, grew up in California or were trained at its excellent art schools and universities. Almost the entire national sculpture movement of the 1970s was spawned here, and now a similar situation exists with painting and with performance and conceptual art.

As we move through the 1990s, there is little doubt that California will remain in a state of comparative grace, even in a turbulent worldwide economic climate. It is simply too well-positioned to be ignored. The state's leaders in all areas—from culture to finance, education to politics, business to recreation—must prepare themselves to take increasingly independent and progressive positions in their areas of expertise. Destiny and a solid economic base seem to be shaping California as the new creative center of the nation. From it will flow the ideas that will feed the future.

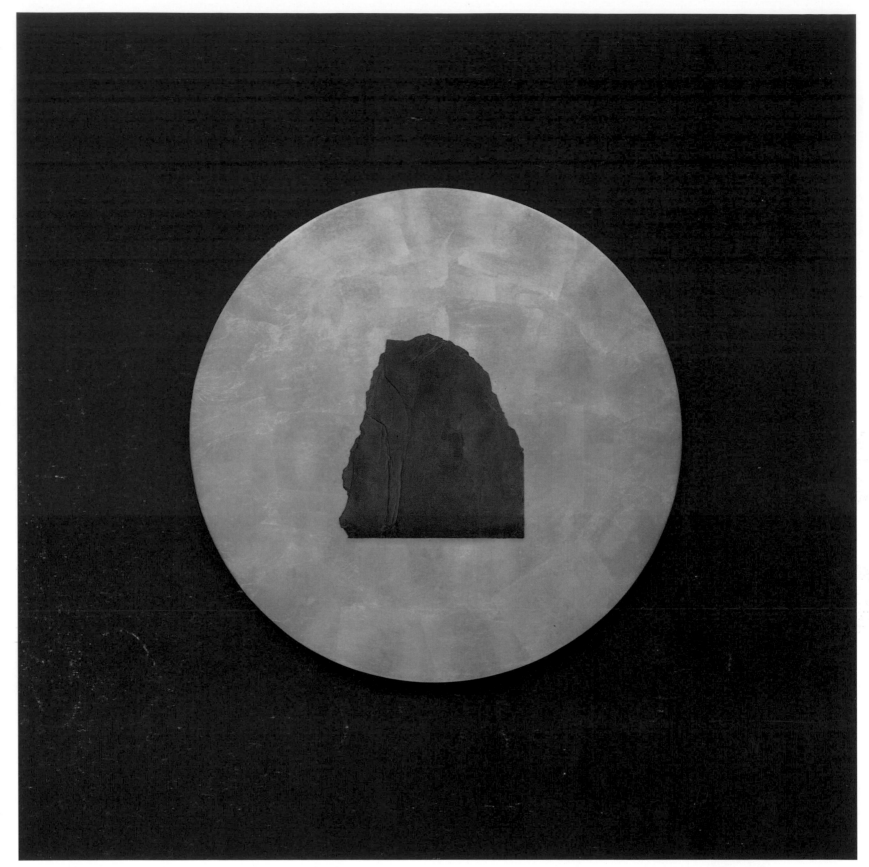

Remembrance I, 1988
Wood, copper leaf, and slate
42 x 42 in.

Lita Albuquerque

16

Lita Albuquerque

Transparent earth, 1988
Oil, pigment, and gold leaf on vellum
57 x 48 in.

From 1978 to 1984 I went from my studio directly out into the landscape to make pieces that posited metaphysical questions about man's relationship to the environment. These works were of an ephemeral nature, using powdered pigments applied directly onto the earth's surface, and they always pointed to certain reference points, whether it was the moon, the horizon line of the ocean, or the mountains. The colors of the pigments were chosen for their symbolic value: ultramarine blue symbolized space, the sky, the planet; copper and gold represented the reflectivity of the planet; and red was energy, both the energy source of the earth and of the internal earth of our being—the fire, the flame that must be maintained.

Since that time the same concern for reference points, our alignments to them, and their placement in the cosmos has evolved from my experience of the ephemeral works into a variety of expression, from poetic narratives, which I incorporated into the paintings and installations, to permanent architectural site-specific pieces, to writings, collaborations, sculptures, and paintings.

My new work is a synthesis of my various concerns over the last ten years, becoming manifest in a series of paintings that take the brilliance of color of the ephemeral works to another level. The works also include text that pushes the viewer to a more complete set of responses. The viewers not only receive information retinally through the brilliant colors, but the words also express verbally what is evoked visually. "They're coming in swarms by the thousands," "It takes a thousand masters praying to melt one heart of stone," "Pyramids are chunks of stars fallen from the sky," are examples of the text used. This work concerns itself with the emergence of light and all that light implies, with the breakthrough of the light force coming through the darkness.

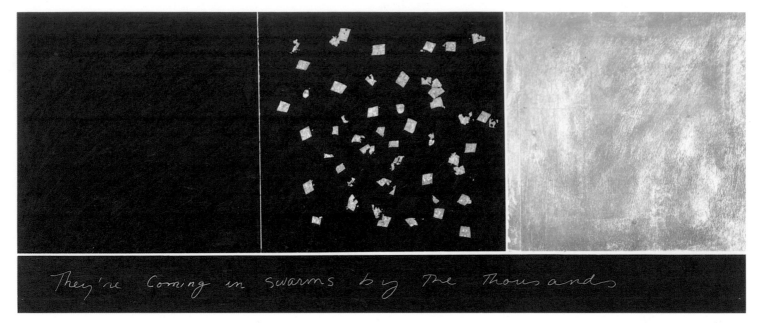

*They're coming in swarms by
the thousands*, 1988
Oil stick and gold leaf on rag paper
25 x 41 in.

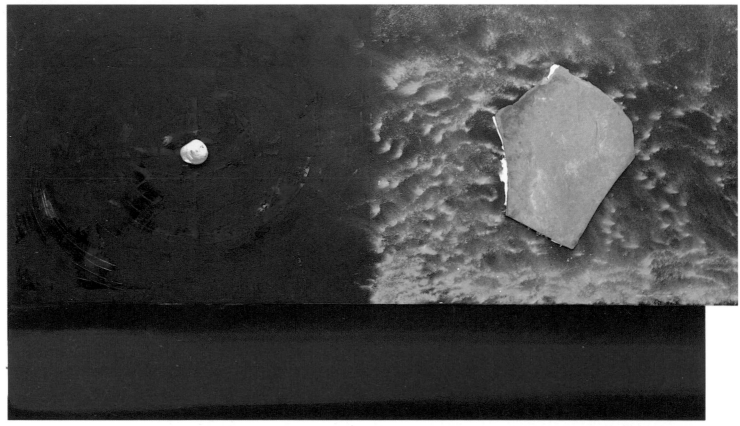

Time Line, 1988
Oil pigment, slate,
and gold leaf on plastered silk
48 x 90 in.

Lita Albuquerque

Peter Alexander

I love making pictures, especially ones that glow.

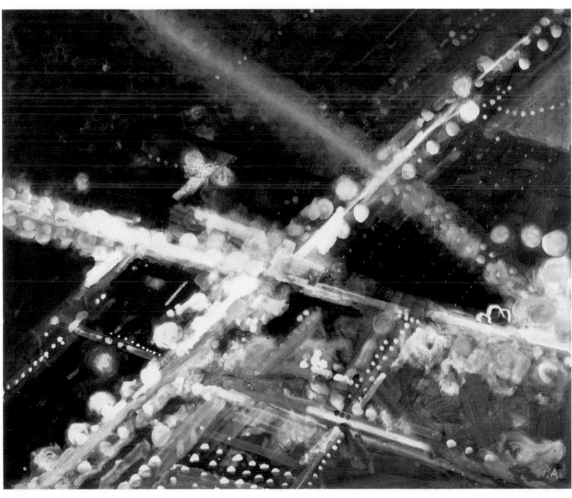

Trader Vic's, 1988
Acrylic and oil on canvas
72 x 84 in.

19

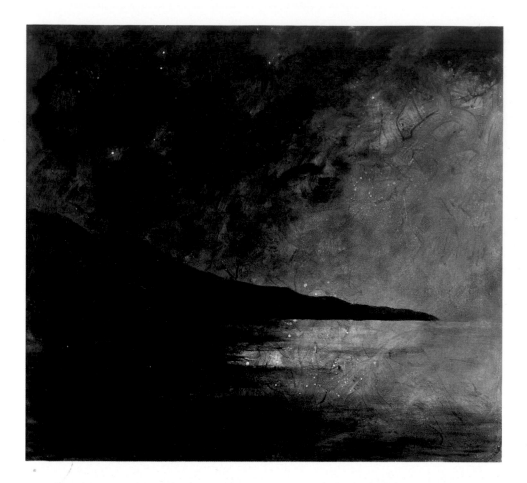

Nicholas, 1987
Oil and wax medium on canvas
60 x 66 in.

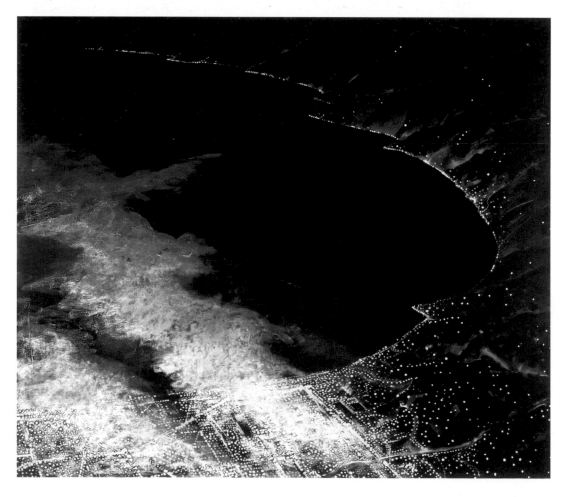

Cloverfield I, 1988
Acrylic and oil on canvas
72 x 84 in.

Peter Alexander

Carlos
Almaraz

I learned to paint on the West Coast, so naturally I inherited several aspects of that school, namely respect for the human figure and a strong interest in color.

After several trips to Mexico I took great interest in murals and developed an understanding of scale. Seeing Tamayo, Rivera, Siqueiros, and Orozco left an indelible impression on me that was to play a vital part in my life and my work during my East L.A. years (about 1972–79).

By 1965 I was ready to visit the big city of New York, the center for American culture. I spent five years studying abstract expressionism, contemporary ideas of minimalism, conceptualism, and performance art. I was very dissatisfied with these movements and even more so with the New York gallery scene, so I

returned to Los Angeles to paint murals in the streets and to help the farm workers, finally establishing my studio in downtown L.A.

I was invited to show with the Jan Turner Gallery, and this has been the single most important event in my career.

I paint and draw what I see, what I feel, and reflect much of my Mexican background in this process.

I am married and have a little girl. My wife is also a painter and we share studios.

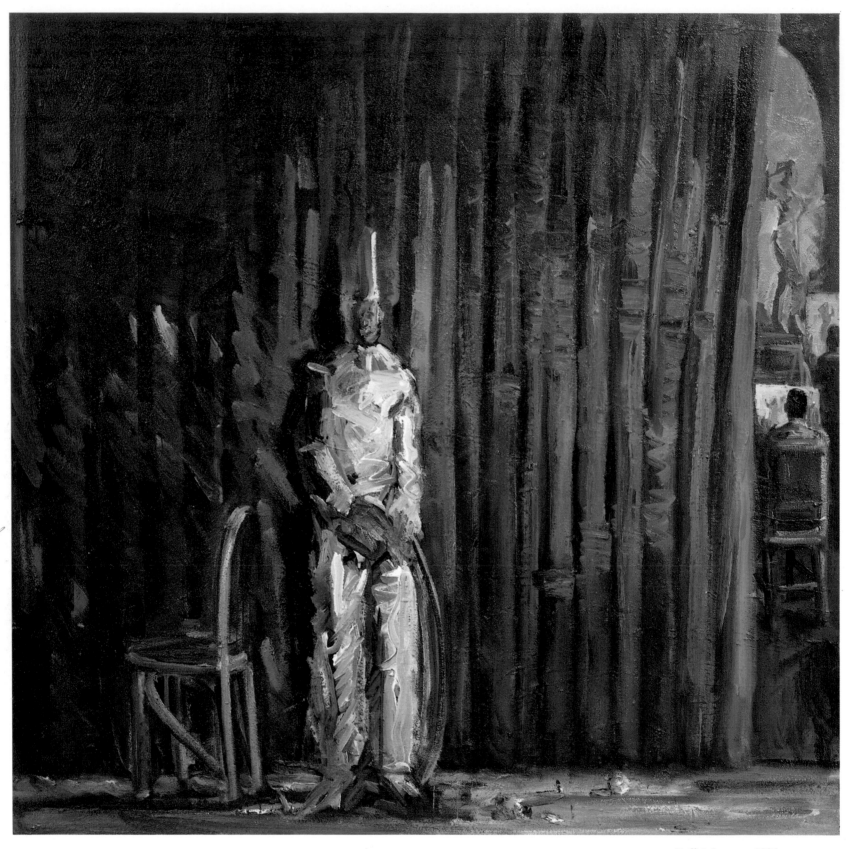

Buffo's Lament, 1986
Oil on canvas
69 x 69 in.

Carlos Almaraz

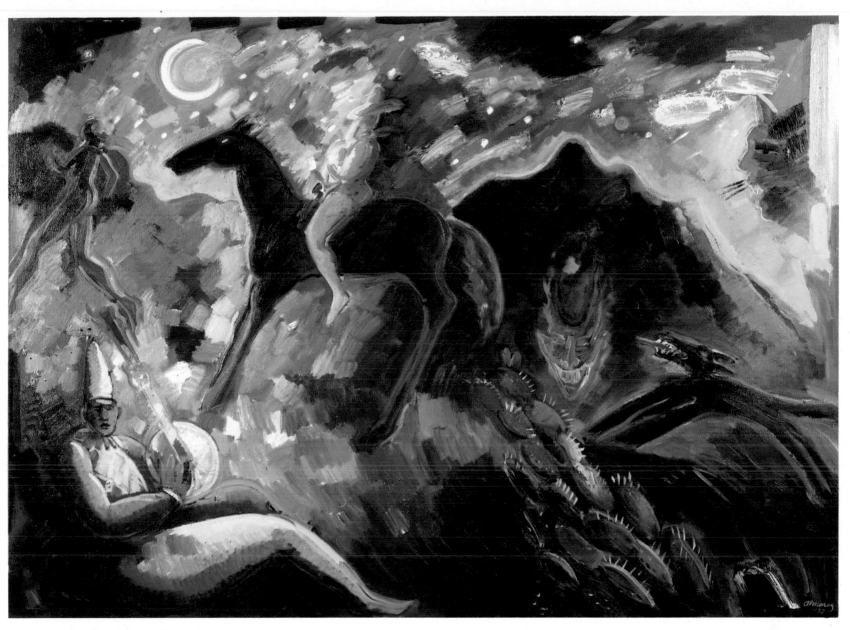

Southwest Song, 1988
Oil on canvas
58 x 80 in.

Carlos Almaraz

Billy
Al Bengston

My work and my life go on. My work is visual,
not verbal. My life is fun.

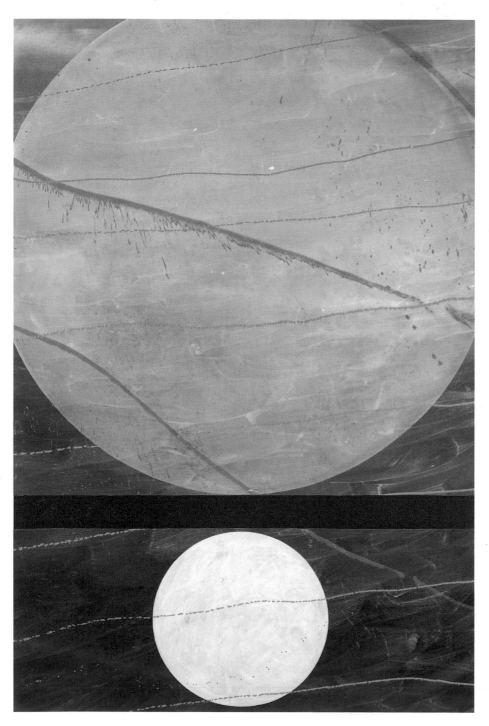

Canton, 1987
Acrylic on canvas
126 x 86 in.

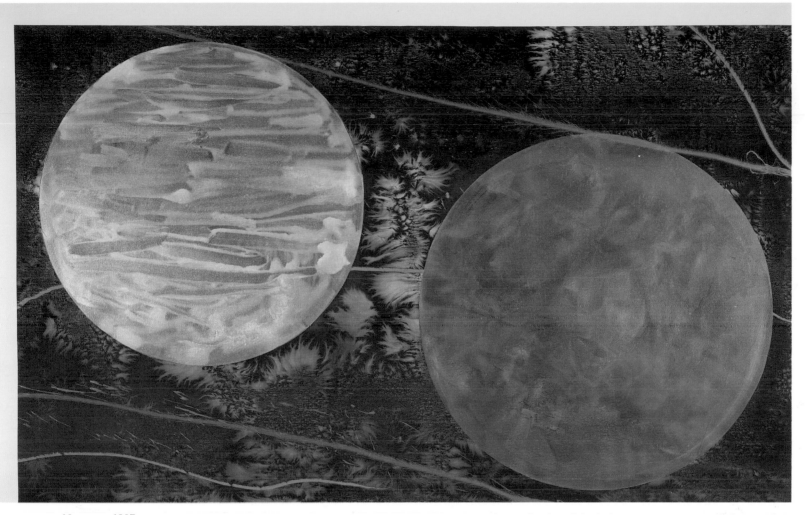

Norcatur, 1987
Acrylic on canvas
86 x 136 in.

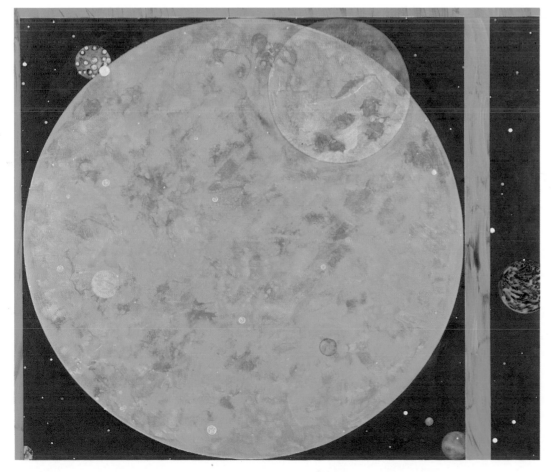

Montebello, 1986
Acrylic on canvas
72 x 84 in.

Billy Al Bengston

25

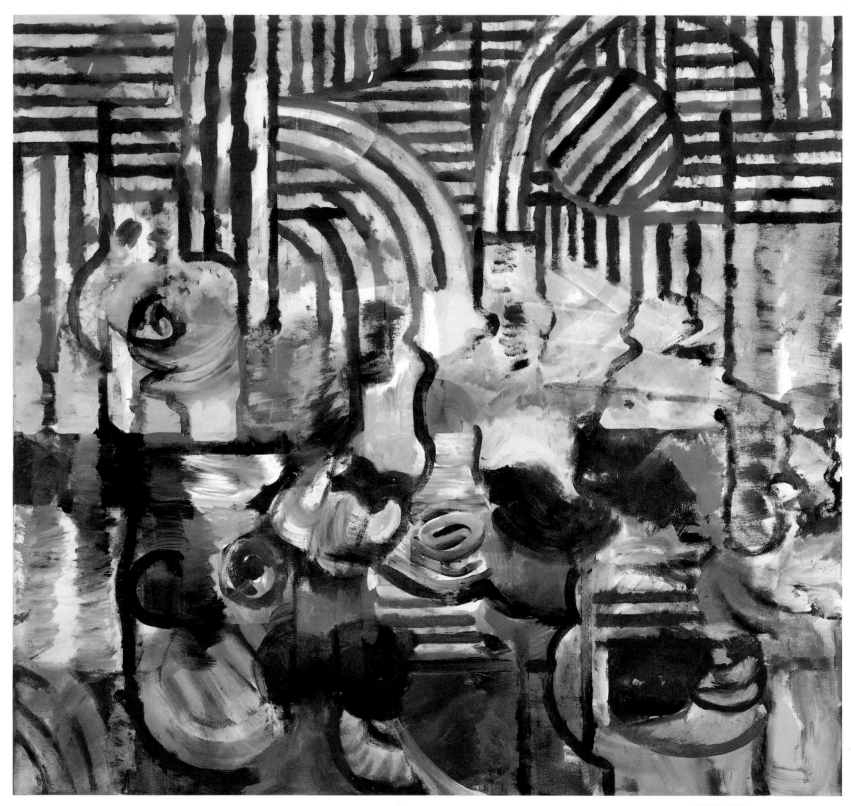

#108, 1987
Acrylic on canvas
80 x 85 in.

Elmer Bischoff

26

Elmer Bischoff

You have to bring off a fusion of your interest both in the subject and in the painting. It's like walking a tightrope. When you are too enamored of nature, you can lose touch with the demands of the painting. Conversely, with too little involvement with the subject, the painting can degenerate into a formal exercise. My aim has been to have the paint on the canvas play a double role—one as an alive, sensual thing in itself, and the other conveying a response to the subject. Between the two is this tightrope.

From *Elmer Bischoff, 1947–1985*

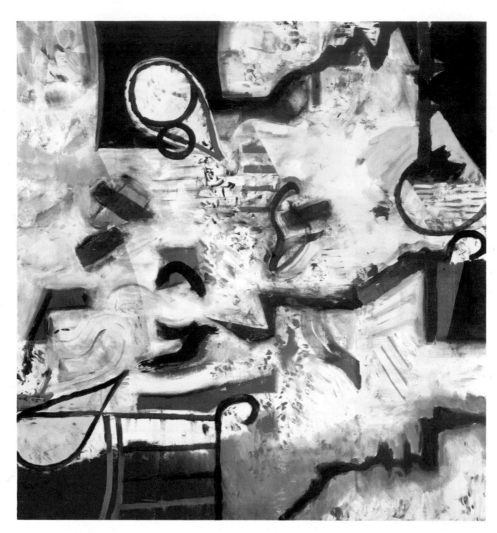

#85, 1984
Acrylic on canvas
85 x 80 in.

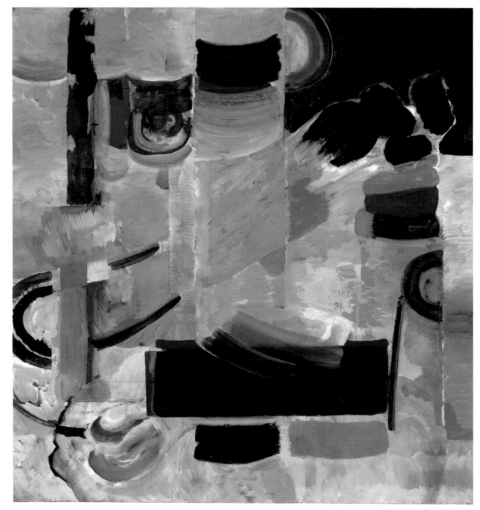

Elmer Bischoff

#109, 1987
Acrylic on canvas
84 x 79 in.

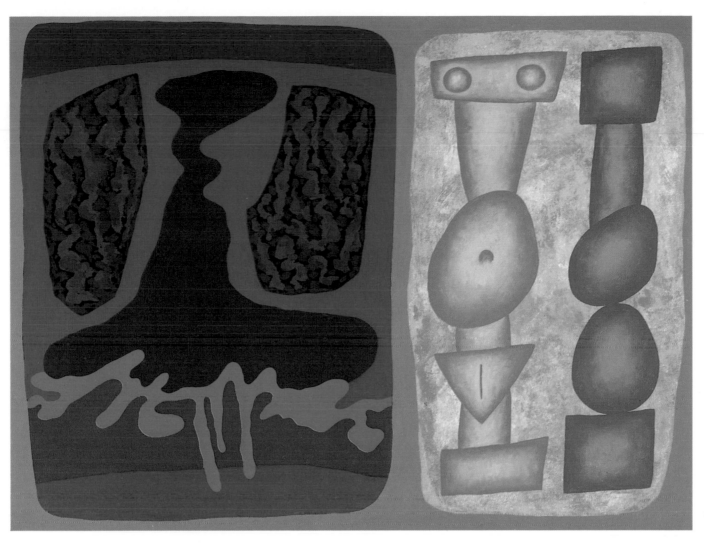

Untitled, 1988
Oil on canvas
18 x 24 in.

William Brice

In painting I work toward realization of a presence true to my experience. My process is both perceptual and conceptual. It involves expression of my state of mind and feeling, and includes my responses, ideas, and beliefs. The interaction in painting between the formal and associative is of particular concern to me. The achievement of presence is like arriving at a destination. I might not know my destination when I start out, but I do recognize it when I arrive.

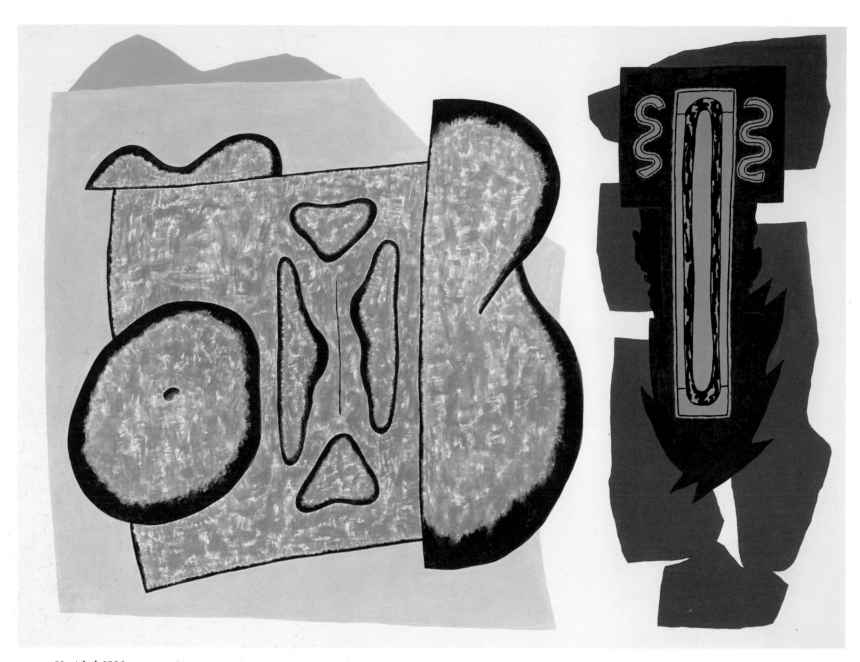

Untitled, 1986
Oil on canvas
72 x 96 in.

William Brice

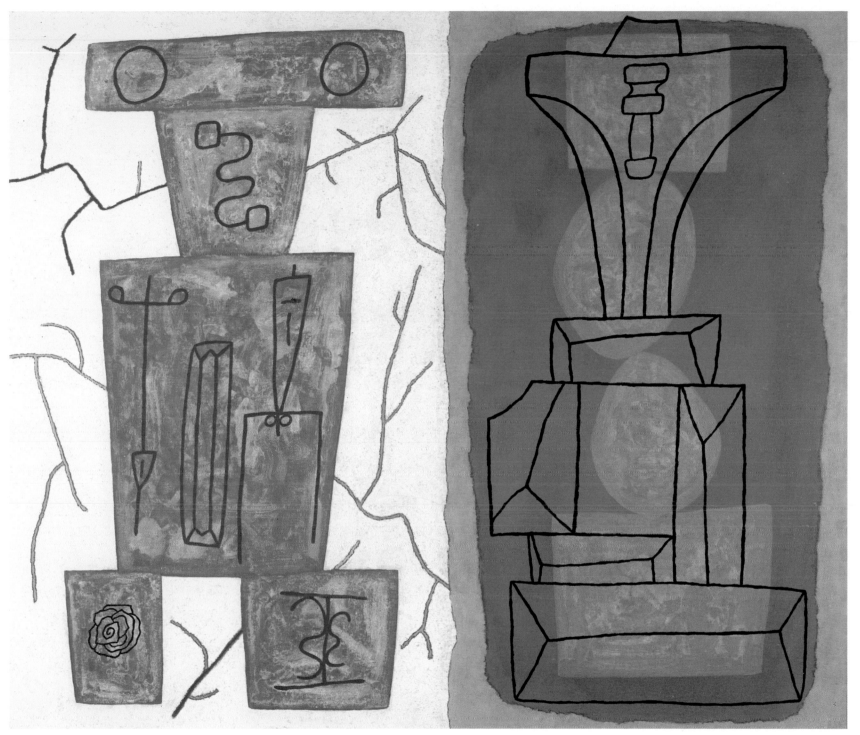

Untitled, 1984
Oil on canvas
50 x 58 in.

William Brice

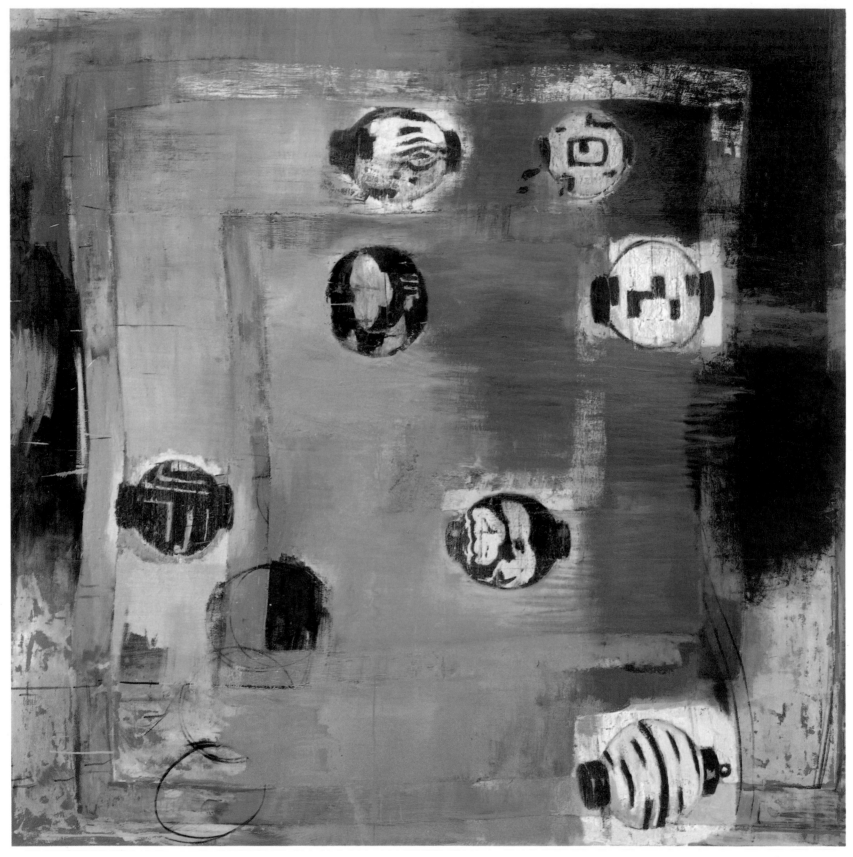

Lights Along the Silk Route, 1988
Oil on canvas
80 x 80 in.

Christopher
Brown

32

Christopher Brown

My paintings are what is left by the time I get to the end. Beneath the level of their pictures, woven into their fabric of marks and erasures, is a record of something that seems like meaning. The images are less important than how they got there, but they always look more so. They allude to content and lend an authority to notions thrown out as suggestions.

But painters are like fishermen: they live life in events below the surface, the next strike counting more than the fish in the creel. It's not pictures I'm after but darks and lights, not images but relationships between them. I'm trying to pare painting down to get to what has to be there. Words come in grunts, my mouth's stuffed with stones, but I'm closer to the point than when every word is clear.

33

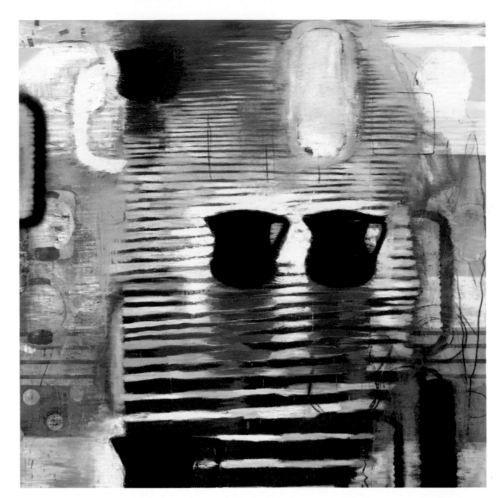

Confluence, 1988
Oil on canvas
80 x 80 in.

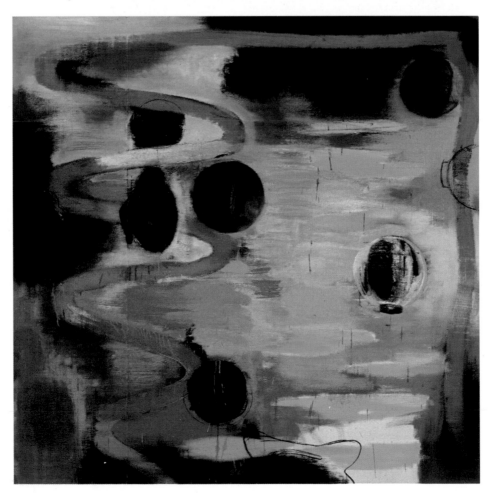

Rivers of the Silk Route, 1988
Oil on canvas
80 x 80 in.

Christopher
Brown

Joan Brown

As discord, chaos, and violence increase in our time, I find myself increasingly motivated to make works of art that reflect peace, harmony, order, and optimism.

For the last three years I've worked on a series of paintings and sculpture that portrays harmony among animals that are usually natural enemies. I also use symbols, imagery, and ideas from the art and architecture of ancient civilizations that I believe were golden ages in the history of the world. In addition to imagery and materials, clear, joyous, and contemplative color is an extremely important element in my work.

Public art projects have occupied a lot of my time in recent years. I favor the idea of public art because it breaks down the exclusivity of the audience, i.e. gallery- and museum-goers, and gives me the opportunity to share my work with many people. Public art also necessitates the interaction and cooperation of several different sensibilities to complete a project, and I find this to be interesting and challenging. When art is in a public place, it becomes a part of society, as it was in ancient times.

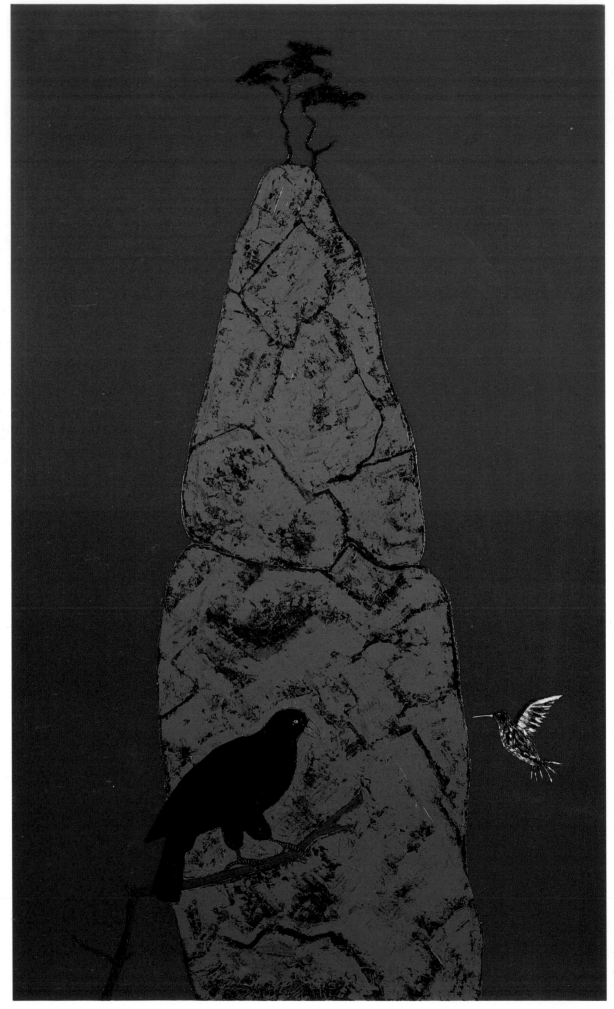

Joan Brown

The Golden Age: The Hummingbird and the Crow, 1985
Oil, enamel, and acrylic on canvas
120 x 72 in.

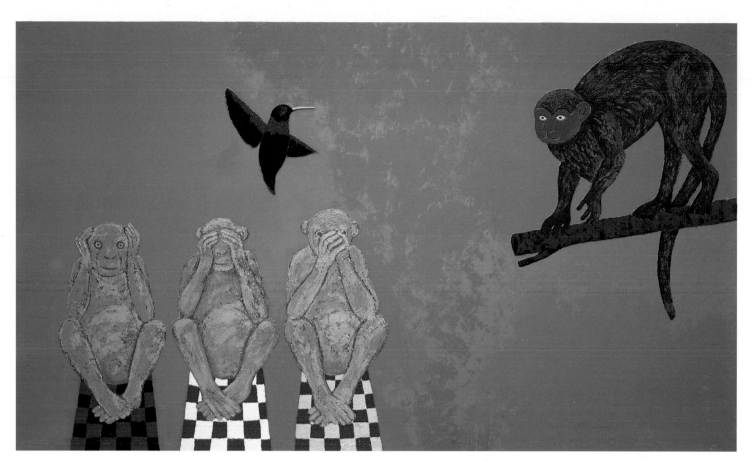

Out on a Limb, 1986
Acrylic on canvas
72 x 120 in.

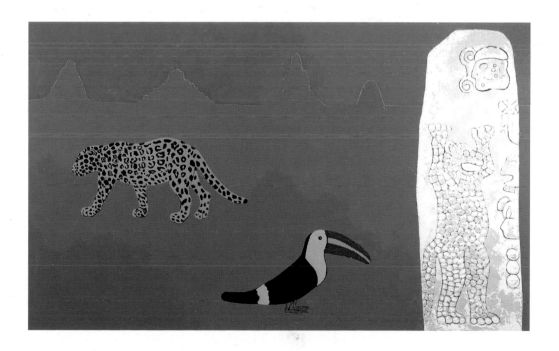

The Golden Age:
The Jaguar and the Toucan, 1986
Acrylic on canvas
72 x 168 in.

Joan Brown

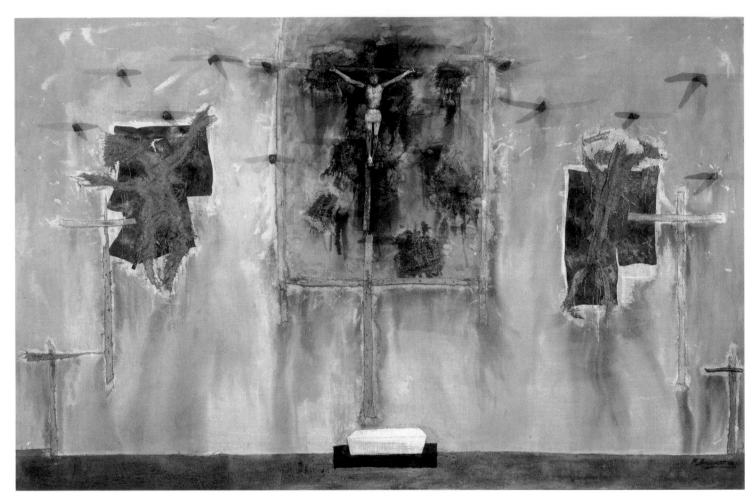

So Near, So Far, 1987
Oil and assemblage on canvas
74 x 114 in.

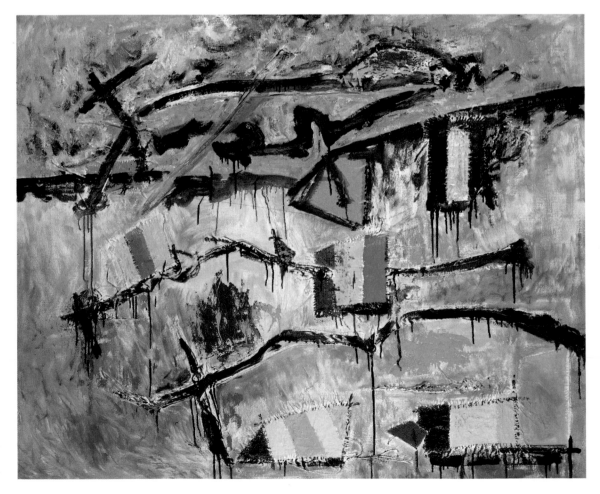

Hans Burkhardt

38

Gardens Again, 1988
Oil on canvas
50 x 60 in.

Hans Burkhardt

When I was a child in Basel, Switzerland, I would go to the museum, where I was most affected by paintings of Böcklin, Grünewald, and Hodler. These paintings have stayed with me all these years.

In the mid-1920s I came to America, where I met Gorky and was introduced to abstract art. I shared his studio for quite a number of years before coming to Los Angeles in 1937. Since then some of my good friends have been artists— Mark Tobey, Irving Block, Raphael Soyer, Lorser Feitelson, and others. They all worked in different styles and somehow never influenced my work. I have always preferred to work alone, except to this day I draw from a model every week in a lab I have at the university at Northridge.

I always prepare my own canvases by hand— stretch, glue-size, and otherwise prepare the surface—before I paint. There's a certain honor in making something with quality.

My ideas for painting come from nature—the figure, landscapes, tortured nails or rusty wires of a city dump, the happy play as well as the sad faces of children, the seeds of a tree falling on the grave of an unknown—and from social and political upheaval.

Because God created nature so beautiful, why should I copy it? I cannot copy it and make it any better, so I make it my own. Look how the world has changed in fifty years. You can't do one painting and make the same thing over and over.

I feel whenever I accomplish something I have to be satisfied, even if it doesn't please anyone else.

I paint the way I live.

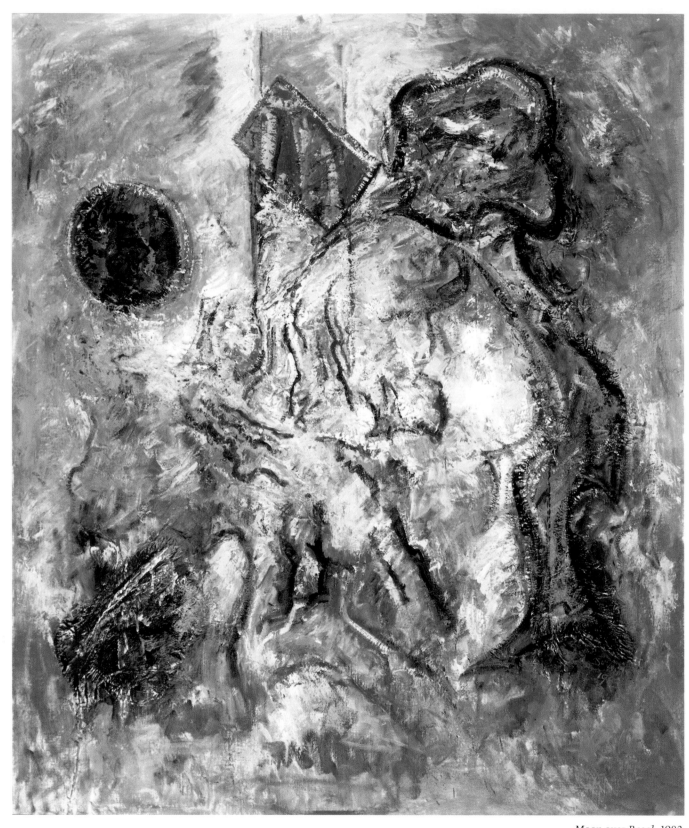

Moon over Basel, 1983
Oil on canvas
60 x 50 in.

Hans Burkhardt

40

Robert Colescott

First of all, I'm a painter and so I want to make paintings that look good, that people are attracted to as sensuous objects, and that have a strong visual presence. I think all that is first; if a painting doesn't have that it hasn't got much.

Second, I want to make paintings that are about things that are interesting. I paint about myself a lot; I'm interested in me. I paint about social things, like race problems—ideas about race, about sex—but I'm just painting about things that interest me. I'm not out to change the world or anything; sometimes people want to know that. But through my work people may focus on important issues and consider how *they* relate to them.

From *The Eye of the Beholder: Recent Work by Robert Colescott*

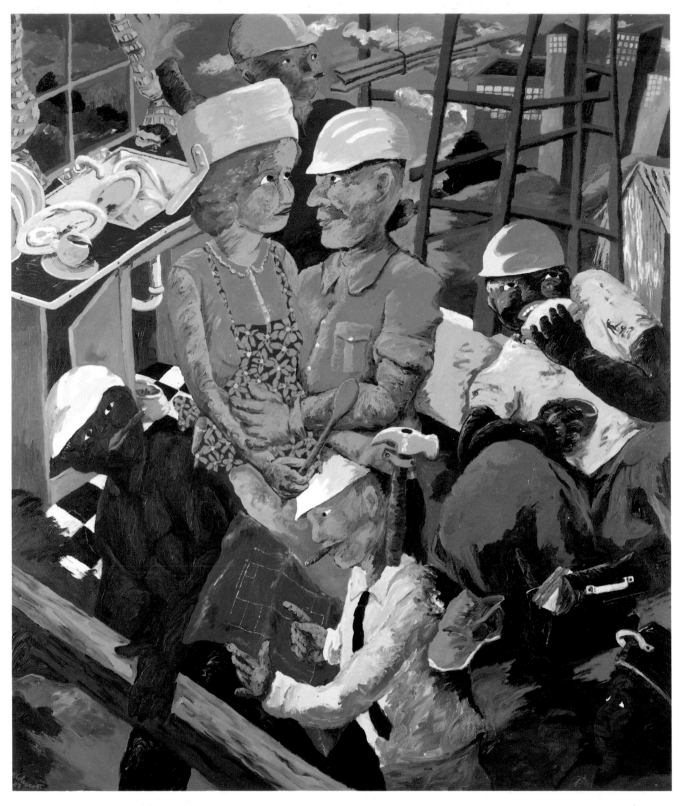

Hard Hats, 1987
Acrylic on canvas
84 x 72 in.

Robert Colescott

42

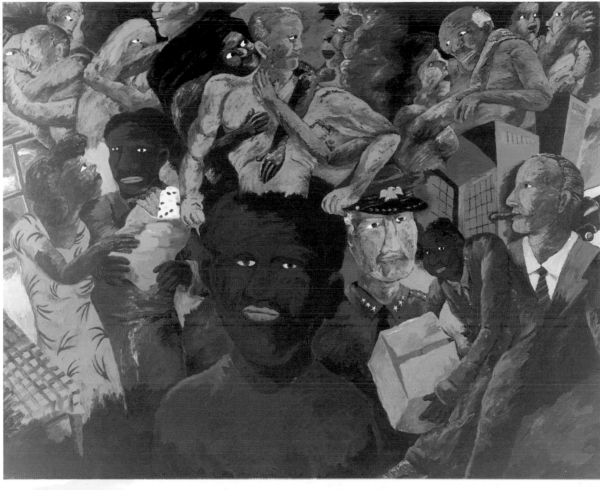

Desire for Power—Power for Desire, 1987
Acrylic on canvas
90 x 114 in.

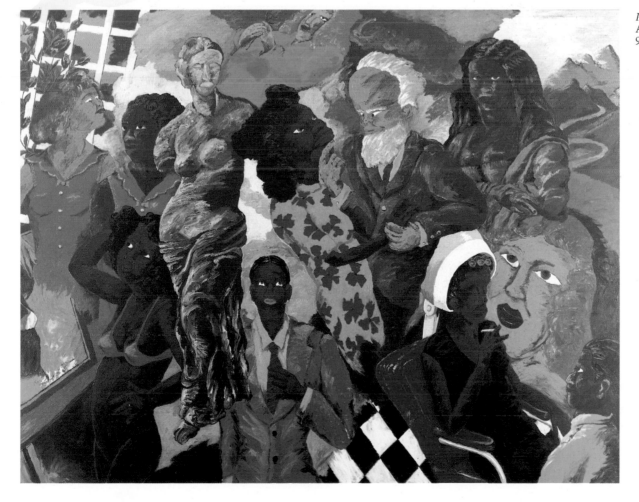

Pygmalion, 1987
Acrylic on canvas
90 x 114 in.

Robert Colescott

43

Mary Corse

I experience the body of my work as a journey in the development of consciousness, in the completion of the psyche.

Beginning with the *White Light* work, my vision is about the internal, immaterial, boundless, spirited side of man. Pulled by the reality of physical nature confined in form—limited— the vision becomes the *Black Earth* work. The journey explores this duality of existence; man being half beast, rooted on this black island of earth, but fueled and inspired by inner radiant white-light consciousness. The energy created by these polar opposites gives centrifugal wholeness.

The gray paintings are about the moment of this relationship, about the interdependency of polar opposites—light/dark, inside/outside, form/formlessness. The paintings are made by the observer's movements and position, which create changing light in relation to an outside object and surface. The observer and the painting are not separate.

Where am I? Where is it? What am I? What is it? The journey is about consciousness recognizing itself.

Black Rainbow, 1987
Micro-glass spheres and paint on canvas
120 x 72 x 1½ in.

Roy
De Forest

One day while talking to an obscure poet, I expressed my belief in the artificer as an eccentric individual creating fantasy art with the amazing intention of totally building a miniature cosmos into which the artful alchemist could retire with all his friends, animals, and paraphernalia

All of us, the obscure poet, myself (obscure visual constructor of mechanical delights), a traveling French Count and his mangy sheepdog, a black mongrel of the night, an obscene hyena, Samuel Johnson (distinguished Terrier), and Rover (domesticated Dingo) shouted, barked, and howled, "Picturesque art is now and forever the hope of the future as well as the dream of the past."

"All too true," lisped the horse of a different color as he stood marking the earth with his translucent hooves. Would that I could have read the significance of those lovely abstract channels chiseled in the moist earth.

From *Roy De Forest: Retrospective*

47

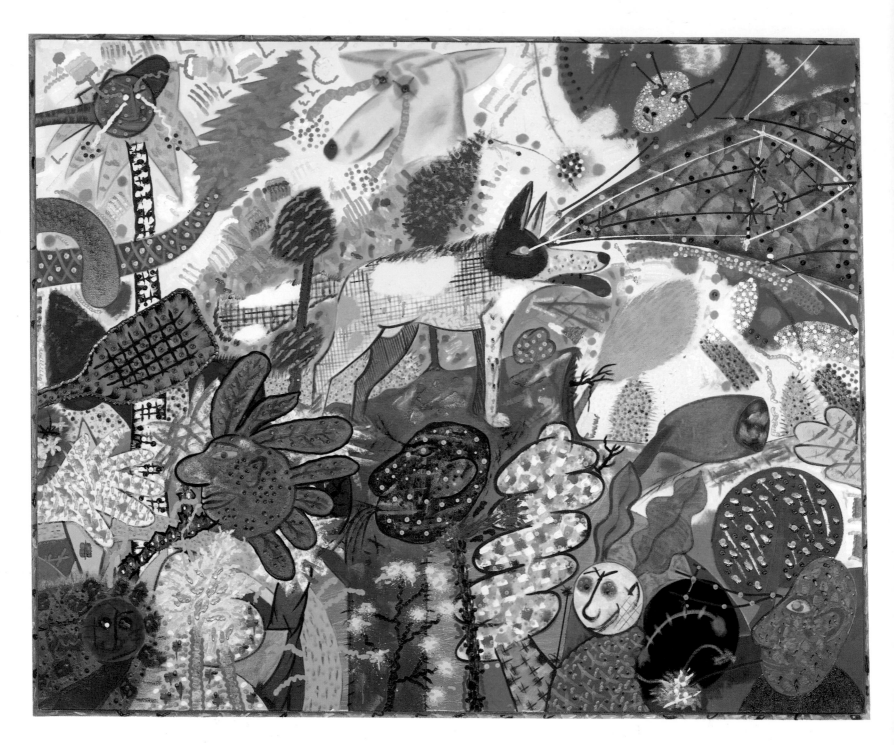

Canis Prospectus, 1986
Polymer and alkyd on canvas
81 x 99 in.

Roy De Forest

48

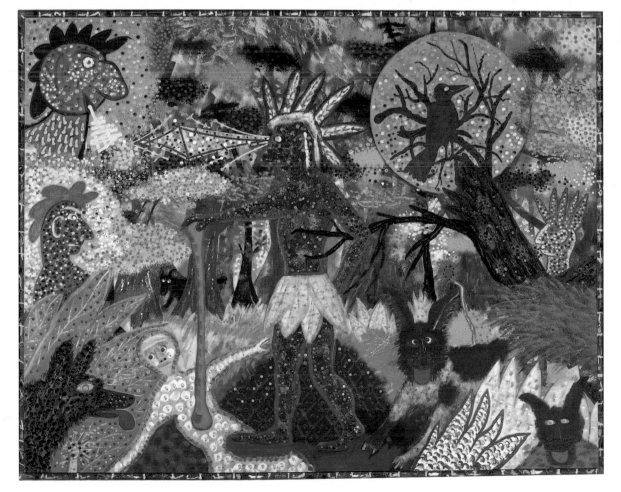

Untitled, 1988
Vinyl and acrylic on canvas
81 x 75 in.

Aboriginal Prospectus, 1986
Polymer and alkyd on canvas
74¼ x 94¼ in.

Roy De Forest

49

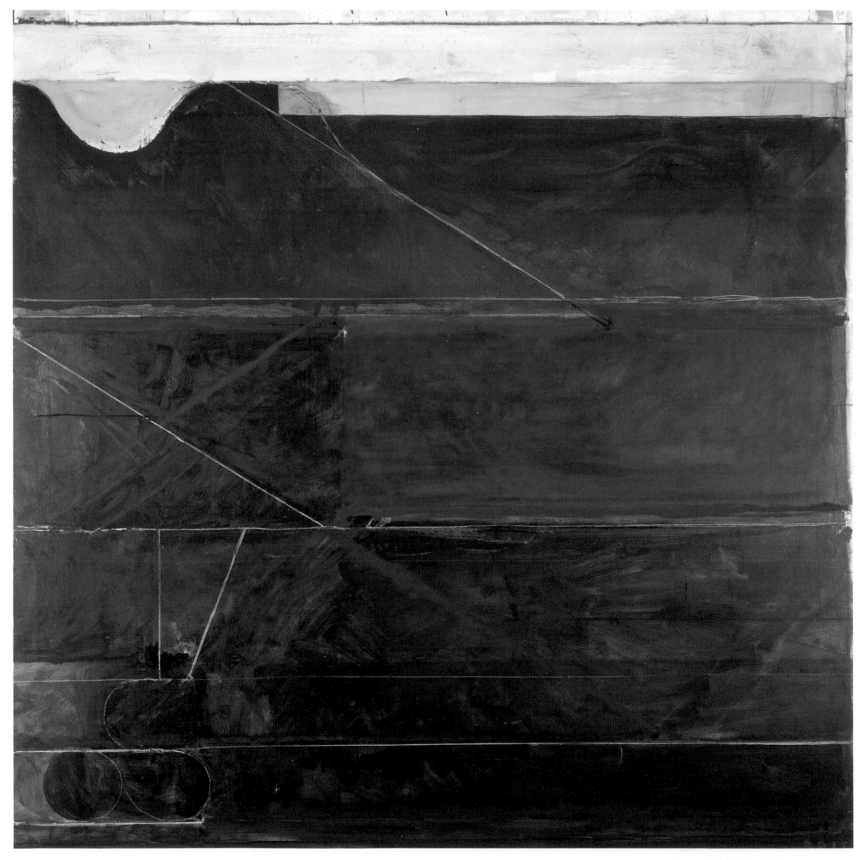

Ocean Park #133, 1985
Oil on canvas
81 x 81 in.

Richard
Diebenkorn

Richard Diebenkorn

When I was young, I used to dream these wonderful images in that strange, suspended state between wakefulness and sleep. In my mind's eye, these images looked like completed paintings, with all their incidentals, but when I awoke and started questioning what was really there I realized that they were dream images—that they were not paintable. In time, too, I began to mistrust my great enthusiasms; I used to run to the studio with some visual idea, but when I tried to give it form, it would look banal and simpleminded. Still, I couldn't dismiss my enthusiasms altogether—they would at least nudge me into a current, a direction. Now that I'm older, I'm not exactly cynical, but I'm no longer so eager about my mental images, either. What matters is when things actually begin to jell on canvas—that's when the real interest begins.

From "Almost Free of the Mirror," by Dan Hofstadter, in *The New Yorker*

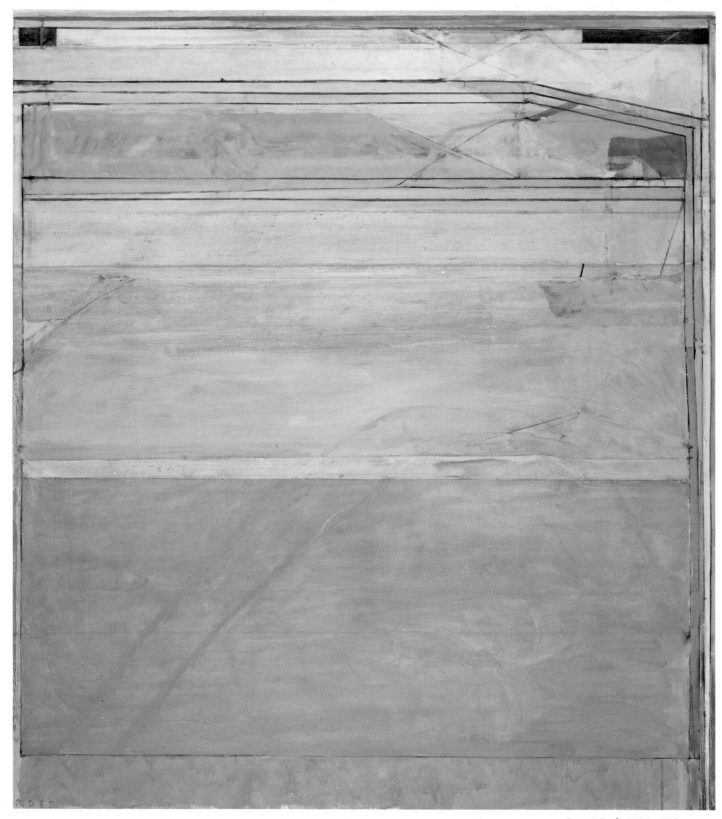

Ocean Park #130, 1985
Oil on canvas
93 x 81 in.

Richard
Diebenkorn

Llyn
Foulkes

I began exhibiting at twenty-six
 critics thought my work was tough
I got in all the art magazines
 museums started buying my stuff.

They made me the belle of the ball
 I could do no wrong at all
 I won the Paris Biennale
 I thought that I would never fall.

But I started doing something different
 they didn't like that very much
 they wanted me to do the same old thing
 they thought I was out to lunch.

They wanted me to be consistent
 to throw away my heart
They wanted me to be nonresistant
 to promote the tradition of art.

I've learned a lot about art
 since I was twenty-six
Like trusting my own solutions
 not worrying about politics.

I think I'm pretty sure what makes real art
 comes from deep inside
Not flippity-flop to get to the top
 or learning to swallow your pride.

Blind Faith, 1985
Mixed media
10 x 7½ in.

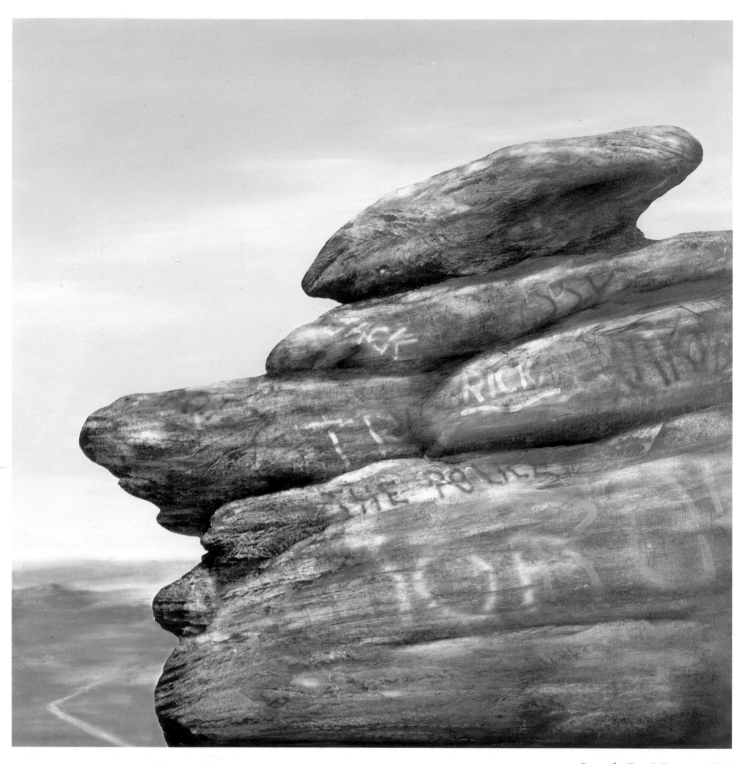

From the Top O Topanga, 1984
Oil on canvas
66 x 65 in.

Llyn Foulkes

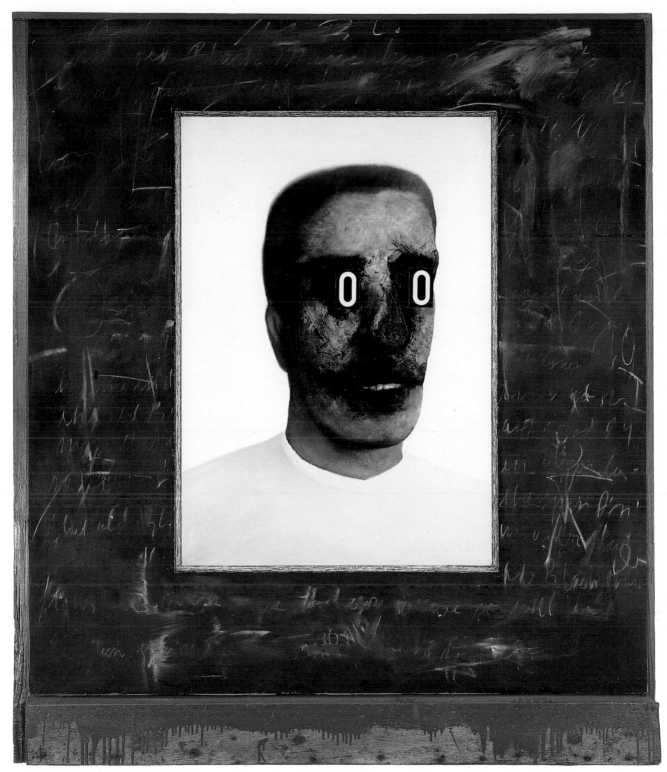

That Old Black Magic, 1985
Mixed media
67 x 57 in.

Llyn Foulkes

55

Sam Francis

I live with the images for years. Living with an image is a very powerful thing to do. It reconstructs your life—if you do it enough.

From *Sam Francis: Paintings on Paper and Monotypes*

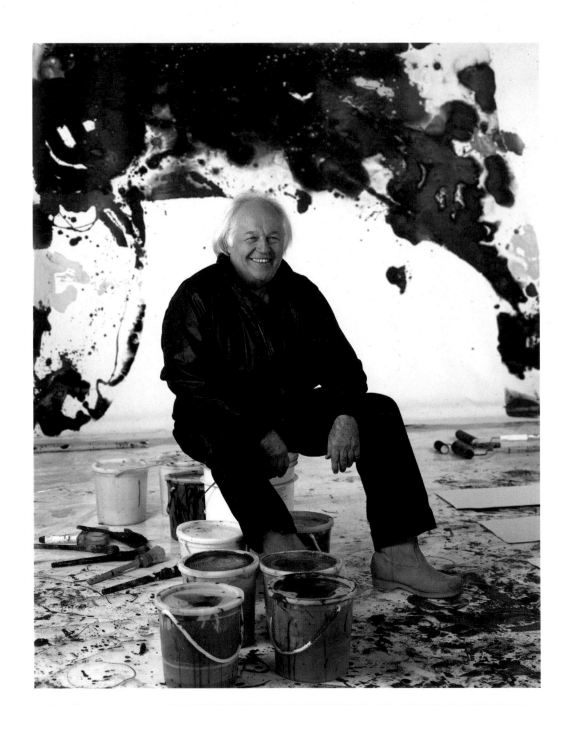

Untitled, 1987
Acrylic on canvas
120 x 60 in.

Sam Francis

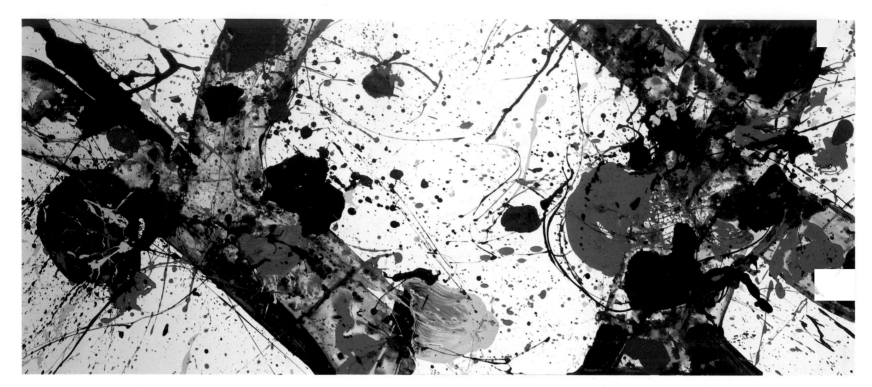

Affective Tension, 1985
Acrylic on prepared board
36 x 84 in.

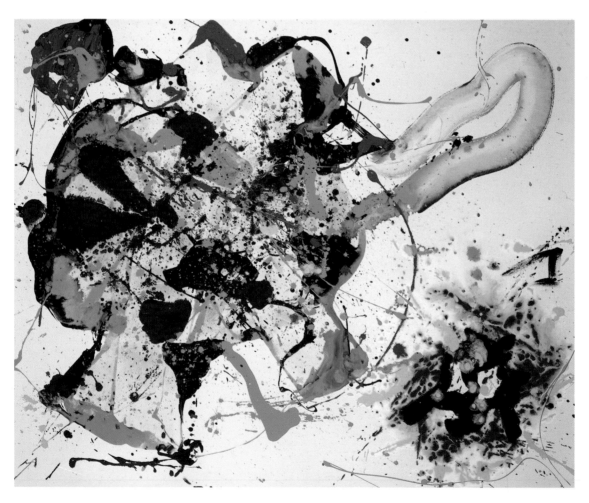

Evergreen Licks, 1987
Acrylic on canvas
60 x 72 in.

Sam Francis

Charles
Garabedian

The older I get, the harder it is to paint. This makes writing about it strange, difficult, and maybe impossible.

The Passing of Montezuma, 1987
Acrylic on canvas
96 x 68 in.

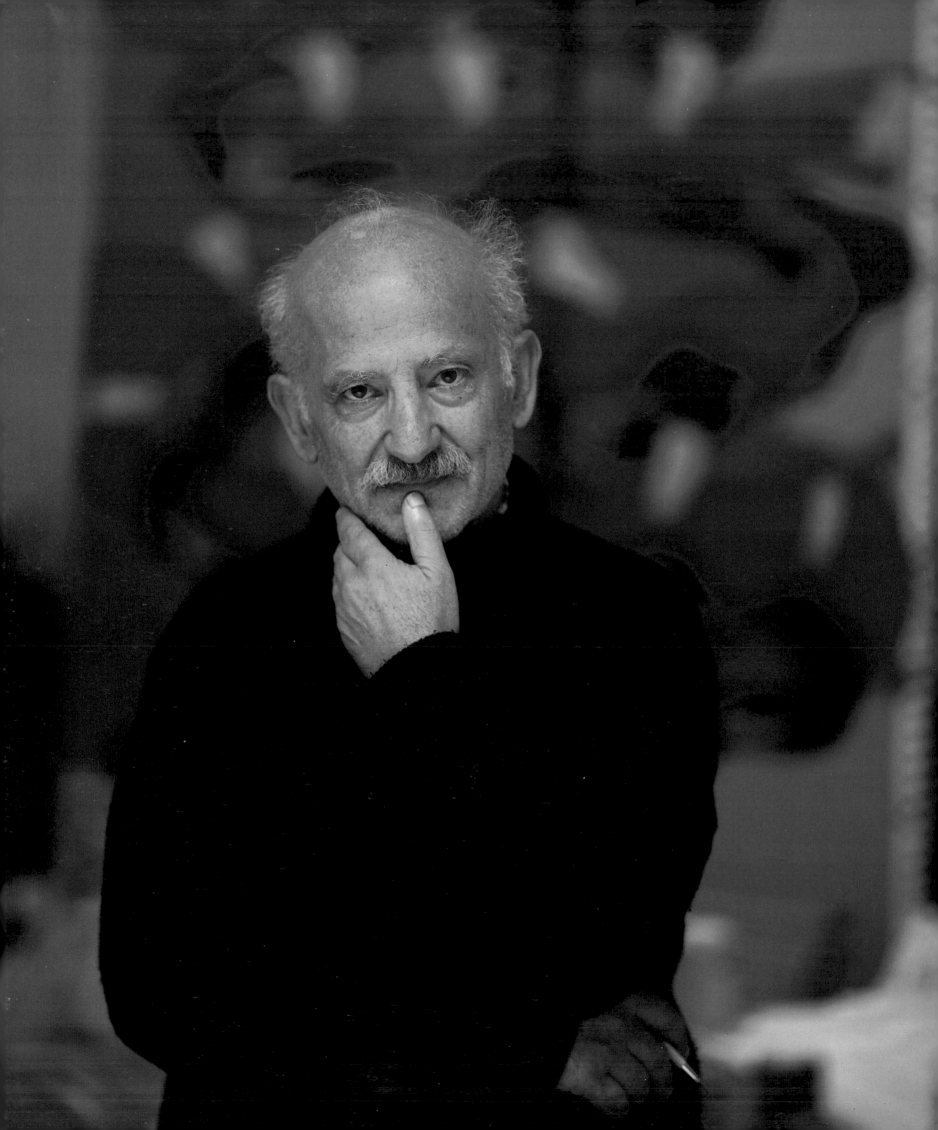

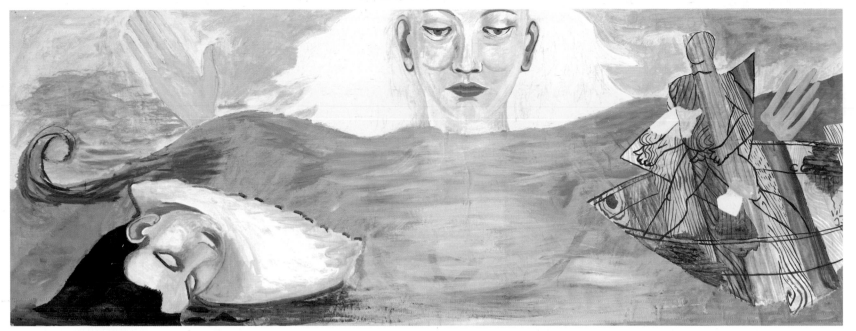

Ulysses, 1985
Acrylic on paper
36 x 94¼ in.

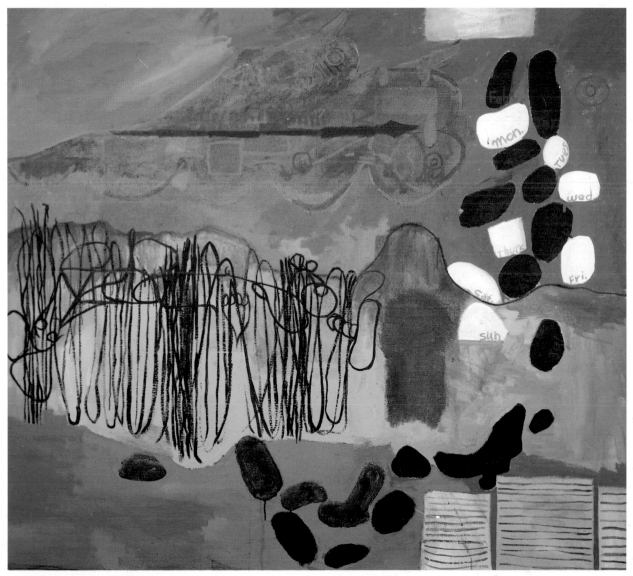

Archipelago of Time, 1986
Acrylic on burlap
68 x 74 in.

Charles
Garabedian

61

Rupert Garcia

I can't ever recall not being astonished by seeing. When I was five years old, my brothers and I made mock tamales using old corn husks for the *hojas*, mud for the *masa*, and water pigmented with red brick-dust for the *mole*. Combining these different things to make simulated tamales struck a chord of joy and wonderment within me. That our imitations appeared edible, but were not, was baffling yet fascinating.

This early state of puzzlement and enchantment continues in the thrill of discovery I experience through familiar and unfamiliar encounters with meaning and feeling. For me, making pictures is the most meaningful, exciting, and challenging way of manifesting those ideas and feelings. The act of painting is in itself a way of knowing and a process of seeing: though my paintings usually start out feeling familiar, they often surprise me by ending up less so.

In 1968, when Marcel Duchamp died and Dr. Martin Luther King, Jr., was assassinated, both of these men's lives began to influence my picture making. From Duchamp I inherited a sense of cultural revolt, especially from his "readymades," which have undermined the whole tradition of high art. King's courageous civil disobedience and his impassioned calls for social change empowered me. Although the impact of these two men appears more enigmatically in my work today, their initial effect remains as strong as ever. It's not that I set out to illustrate what Duchamp and King said or did; rather, they helped develop my views at a crucial point in my life.

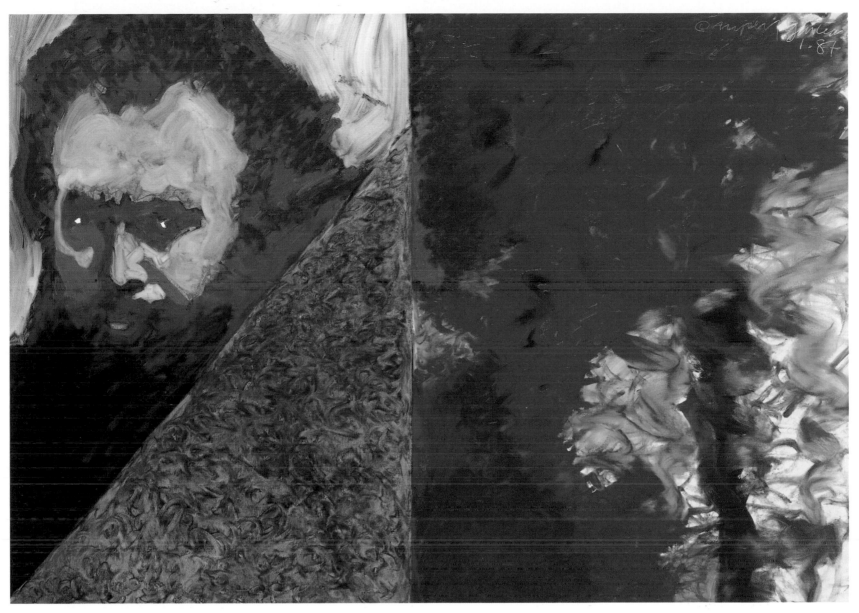

Manet-Fire, 1987
Chalk, linseed oil, and
oil paint stick on canvas
45¾ x 66 in.

Rupert Garcia

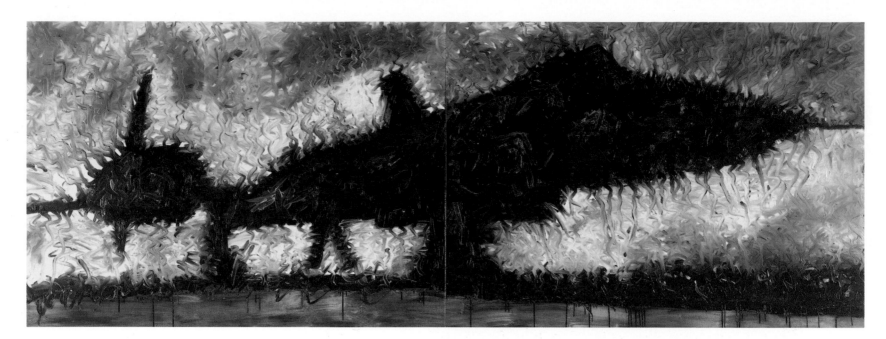

Ominous Omen, 1987
Chalk, linseed oil, and
oil paint on canvas
47 x 130 in.

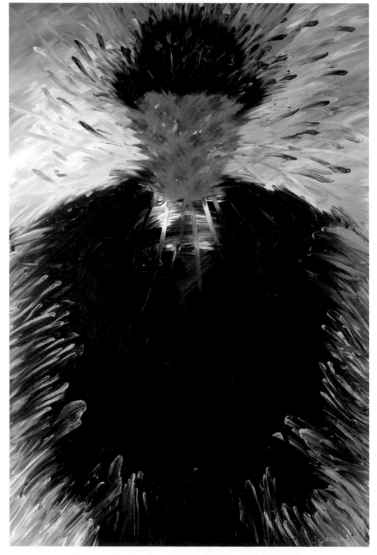

Magritte Remembered, 1987
Oil on linen
73¾ x 48⅝ in.

Rupert Garcia

Jill
Giegerich

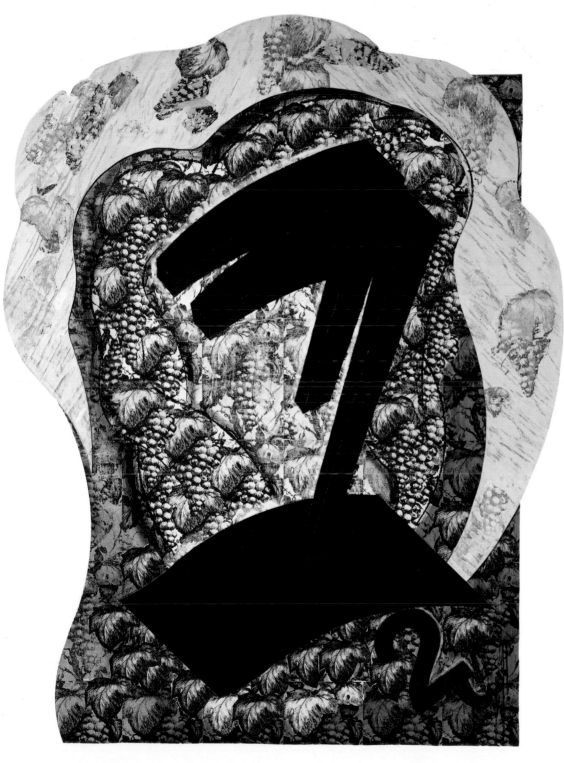

Untitled, 1988
Rubber, Xerox, shellac with pigment,
charcoal, and paint stick on gessoed plywood
91¼ x 70¼ in.

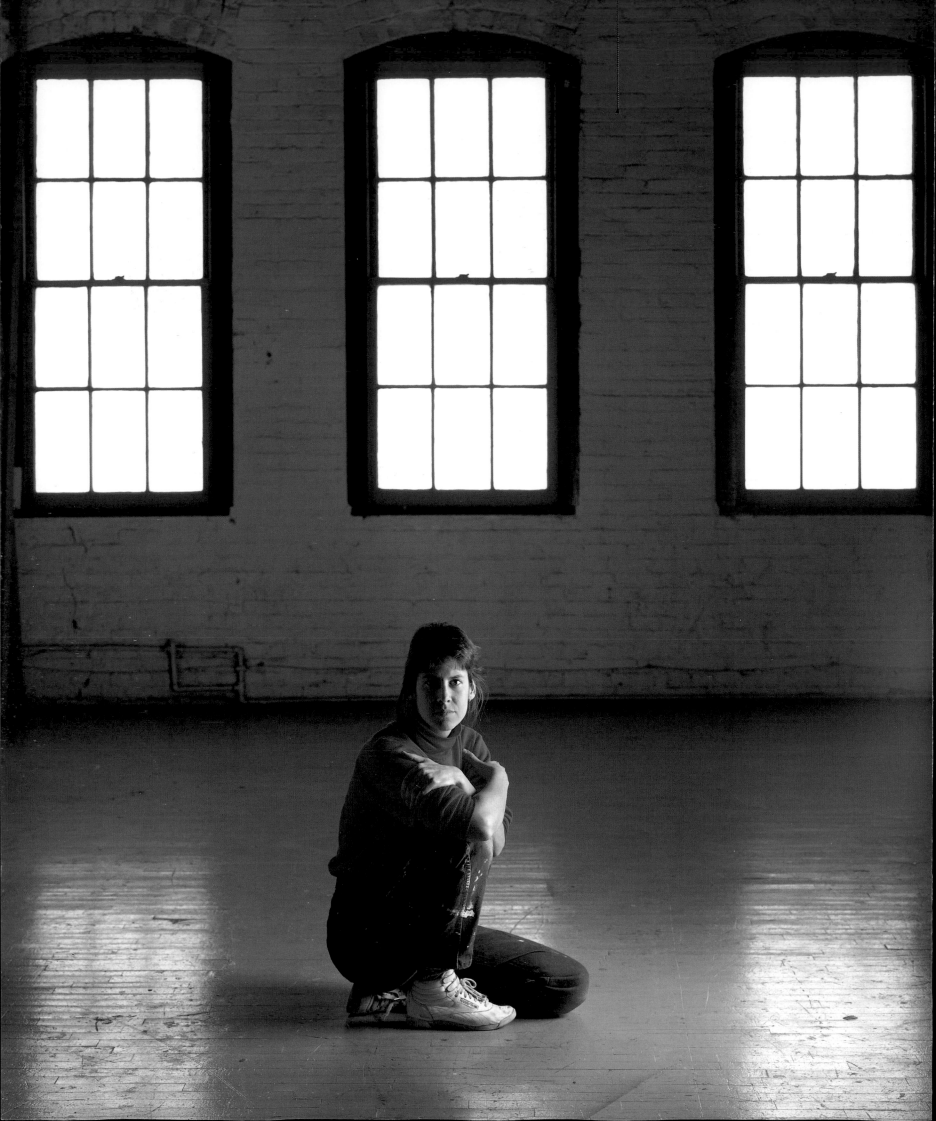

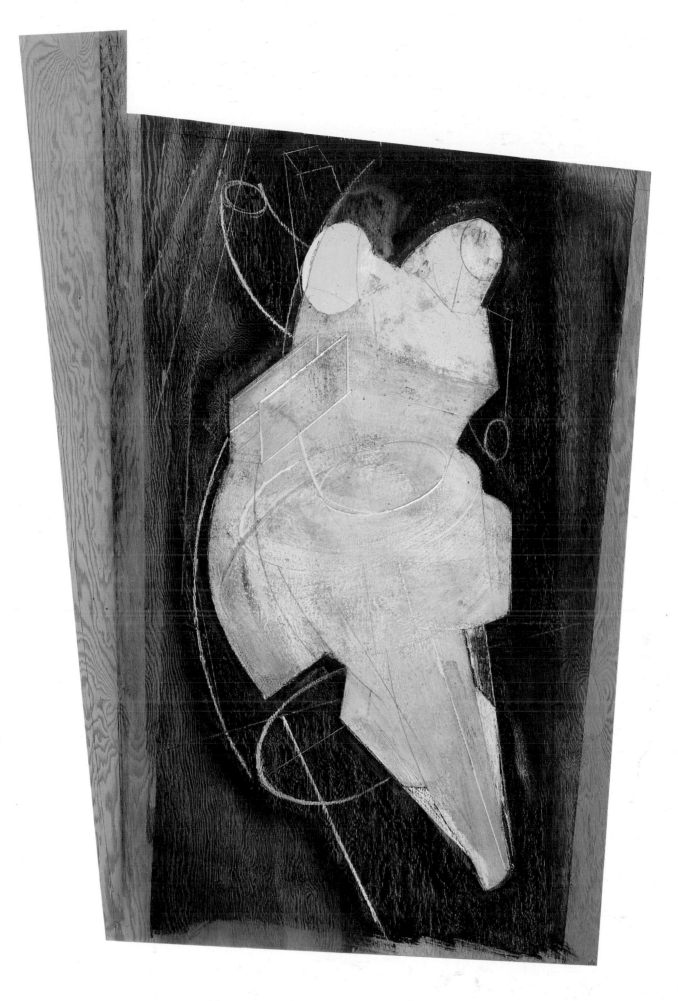

Untitled, 1986
Beeswax, acrylic, charcoal graphite,
and india ink on plywood
61 x 39¼ in.

Jill Giegerich

67

Joe Goode

Untitled, Ocean Blues #9, 1988
Oil on wood
90 x 84 in.

Untitled, Ocean Blues #4, 1988
Oil on wood
54 x 72 in.

Joe Goode

69

Roger Herman

I always thought my paintings were abstract. When I use a figurative iconography, the images are known but empty. The pictures are excuses to make paintings, going through history backwards until you find a new start, a new reason: putting painting on its feet.

Untitled 12, 1988
Oil on canvas
36½ x 36½ in.

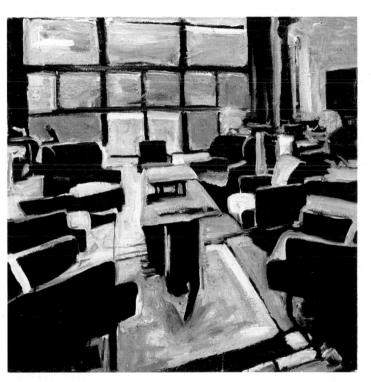

Untitled 10, 1988
Oil on canvas
36½ x 36¾ in.

Bungalow, 1988
Oil on canvas
96 x 192 in.

Roger Herman

72

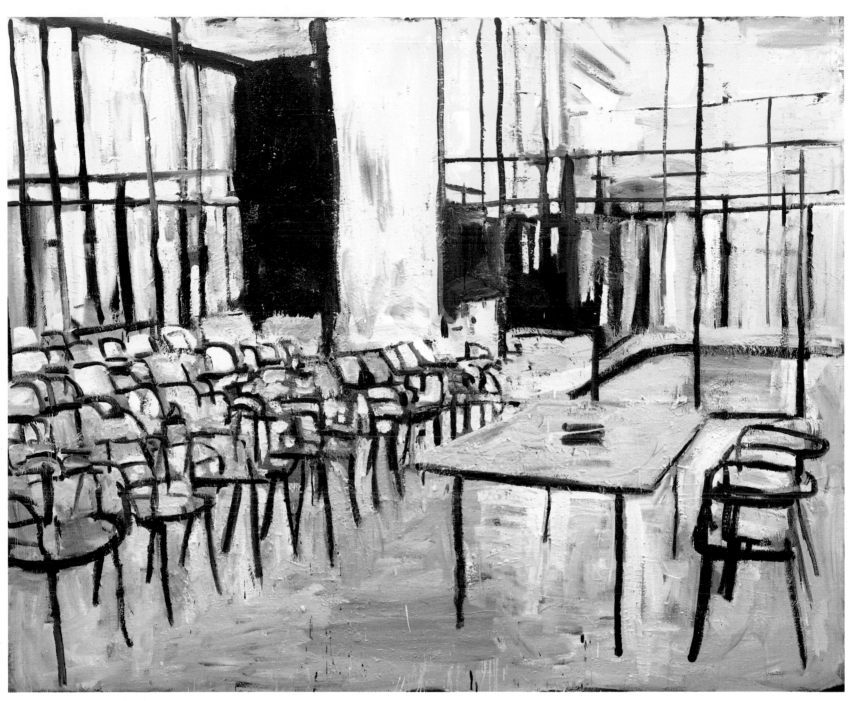

Yellow Auditorium, 1987
Oil on canvas
108 x 144 in.

Roger Herman

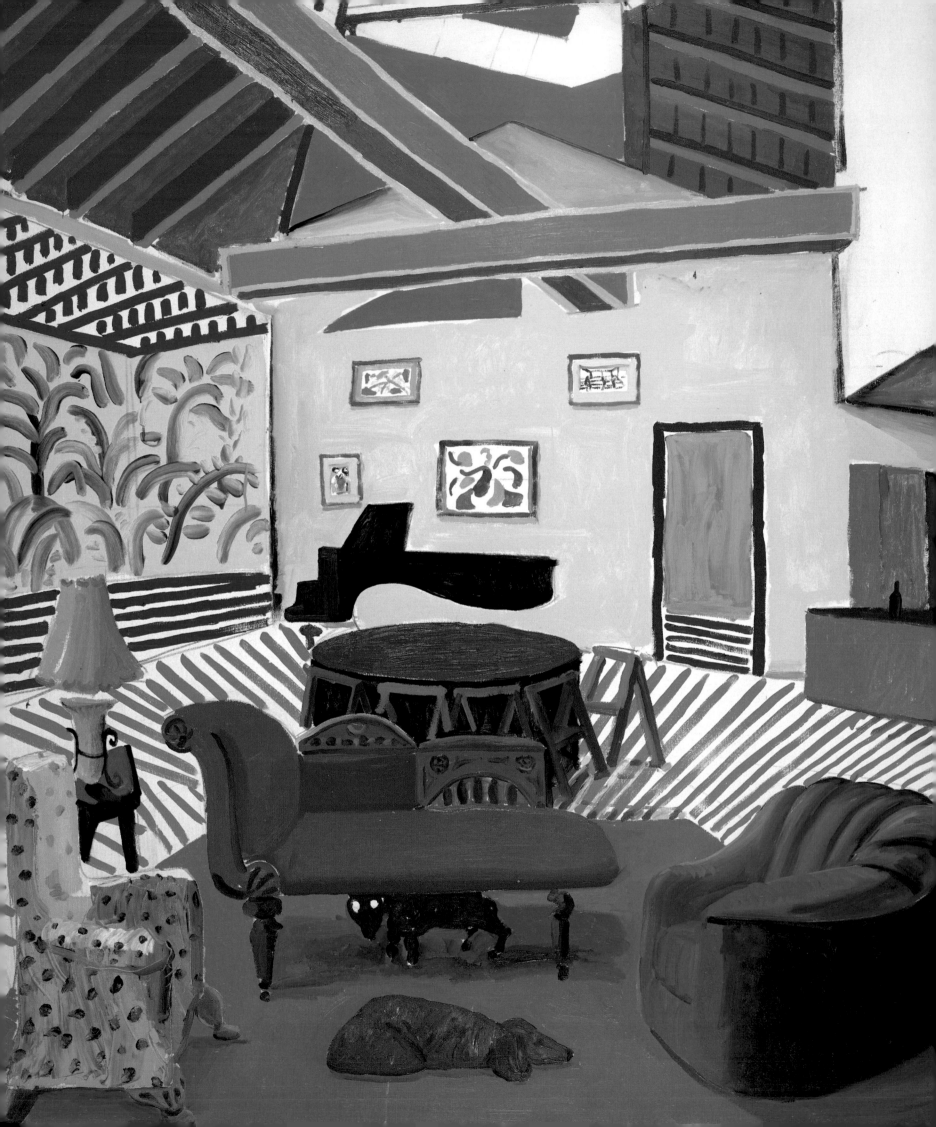

David Hockney

Look at how a child draws a house—you get the front, the sides, the back, the backyard tree, everything all jumbled together—and then the teacher comes and says, "Wrong, wrong. You can't see all those things at once. Do it this way instead."... A child draws a landscape, and he draws the earth at the bottom of the piece of paper, a brown line, and the sky at the top, a blue line, and a tree in the middle, perched on the brown line of the earth. And the teacher comes along and says, "No, no. Wrong. You don't need two lines because, well, there's only one line, in the middle, where the sky and the earth meet." Which is true in a way, but it also fails to acknowledge the piece of paper. What the child has done is taken that piece of paper and said, "When you look up at the sky, that's the top of the page, and down at the ground is the bottom." And that is an exact translation of sky and earth made onto a piece of paper. The other way you're looking through the piece of paper, as if it weren't there. But the child knows it is there and is dealing with that surface, at least until the teacher teaches him not to see it.

From *David Hockney: A Retrospective*

Montcalm Interior with Two Dogs, 1988
Oil on canvas
72 x 60 in.
© David Hockney

Tristan und Isolde II, 1987
Acrylic on canvas
10⅝ x 13¾ in.
© David Hockney

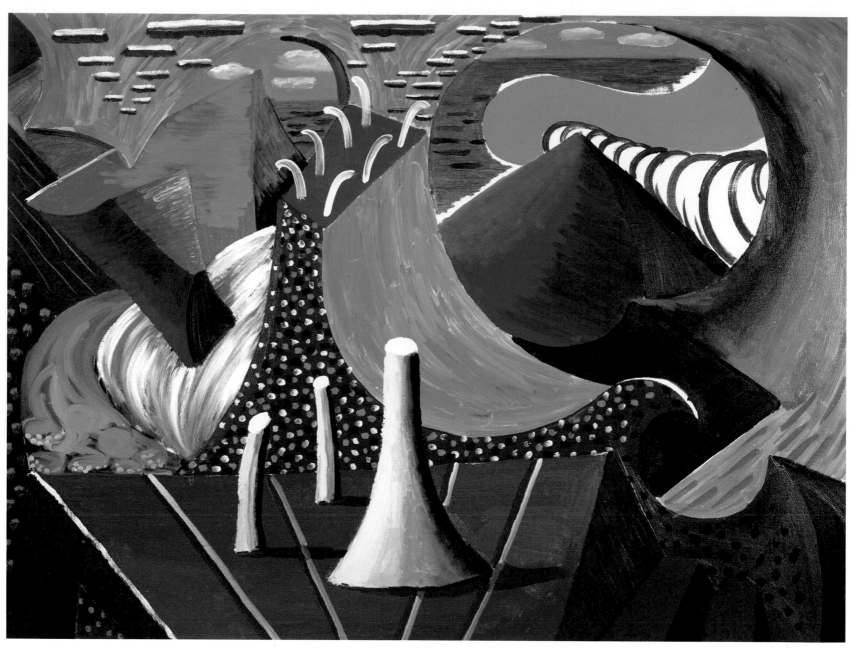

The Sea at Malibu, 1988
Oil on canvas
36 x 48 in.
© David Hockney

David Hockney

Robert
Hudson

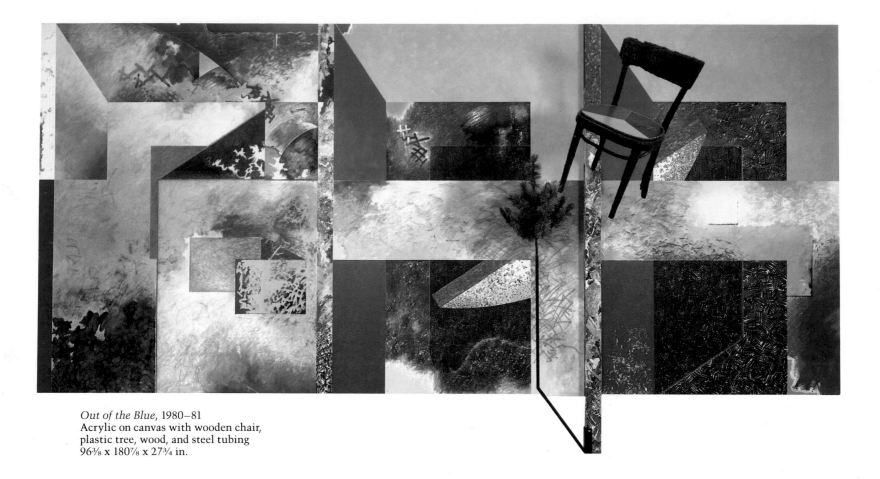

Out of the Blue, 1980–81
Acrylic on canvas with wooden chair,
plastic tree, wood, and steel tubing
96⅜ x 180⅞ x 27¾ in.

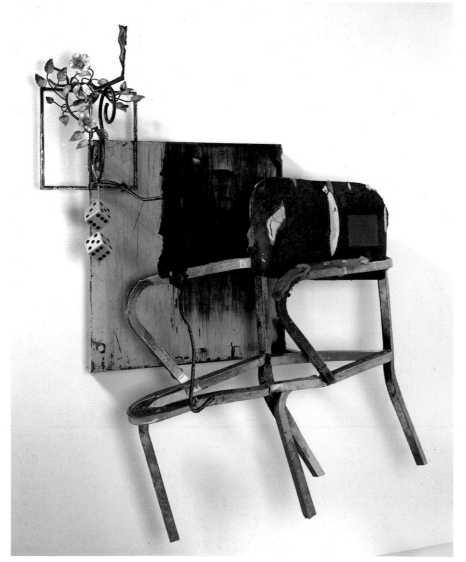

Robert Hudson

Chair, 1988
Acrylic paint, steel, vinyl, enamel paint,
squashed chair, foam rubber, and plastic dice
54 x 42 x 18 in.

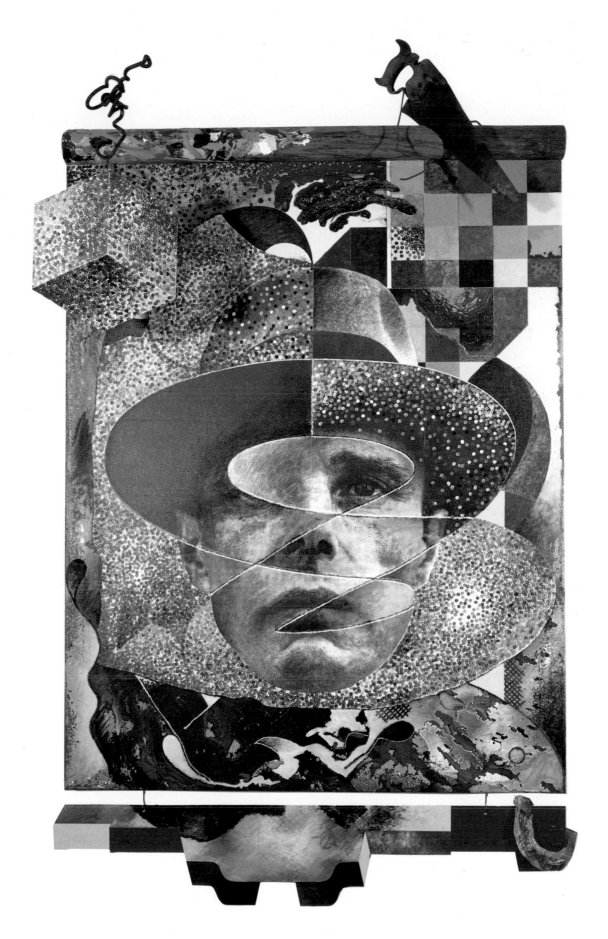

Untitled, 1980–81
Acrylic, charcoal, enamel paint,
collage on canvas, wood, masonite,
tin, finishing saw, and wire
76 x 46 x 21 in.

Robert Hudson

79

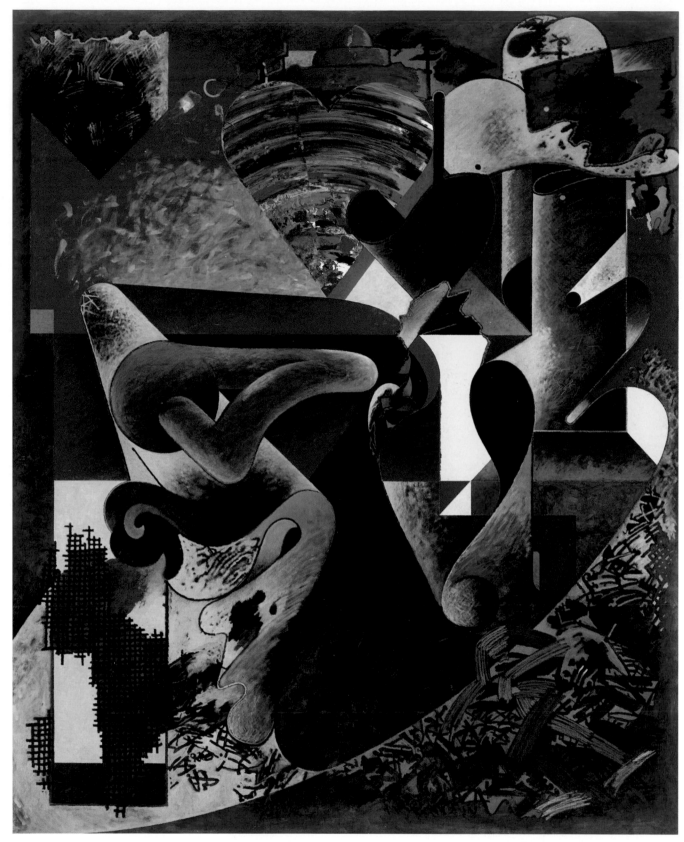

Art Felt Swoop, 1982
Acrylic, pastel, and charcoal on canvas
74¾ x 61¾ in.

Robert Hudson

80

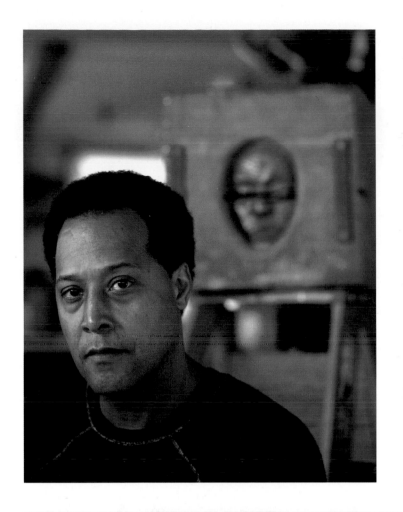

Oliver Jackson

Because visual language is not translatable, it is essential that the works address the fundamental nature of form. My paintings attempt, through their use of form, to transcend the tangible reality of the physical substance of paint in order to achieve a mode of reality that is spiritual in nature.

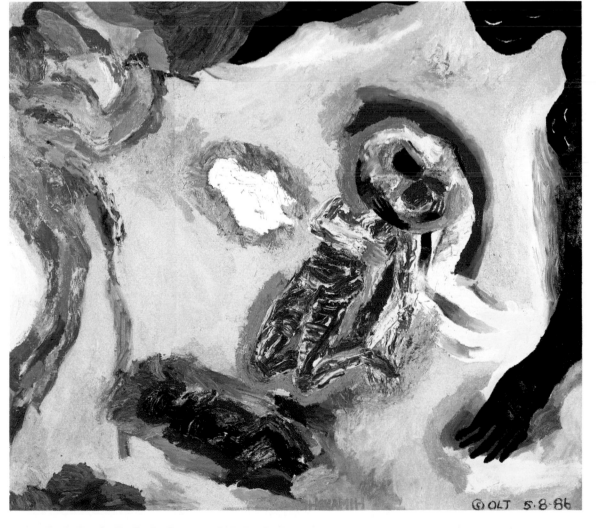

Untitled (5.8.86), 1986
Oil on linen
95¾ x 108 in.

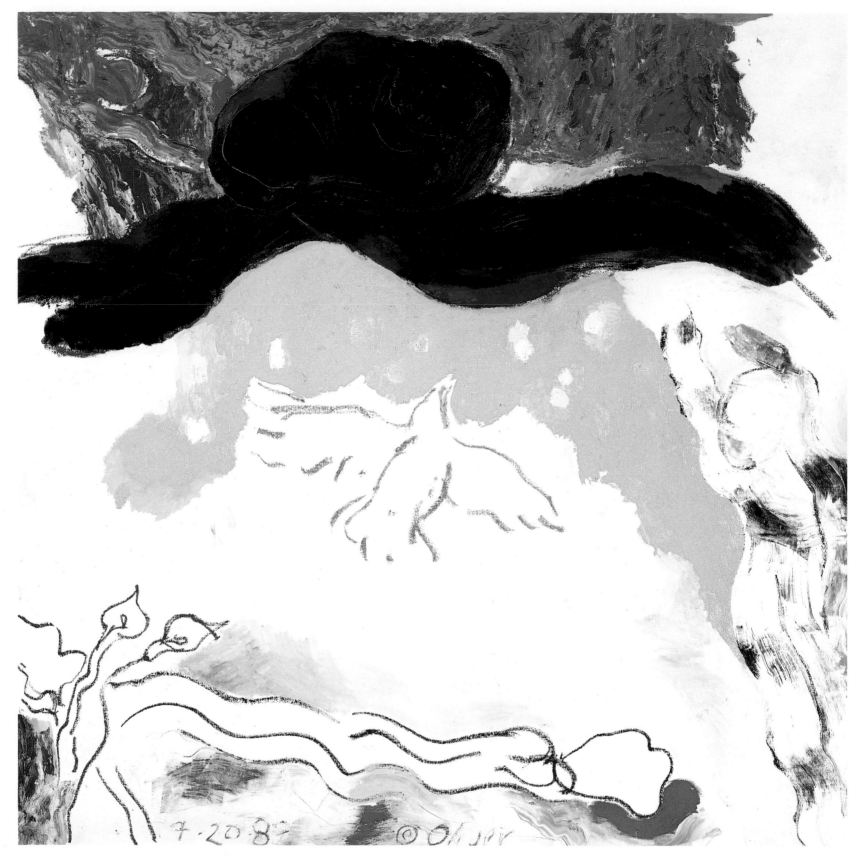

Untitled (7.20.87), 1987
Oil and oil pastel on linen
108 x 108 in.

Oliver Jackson

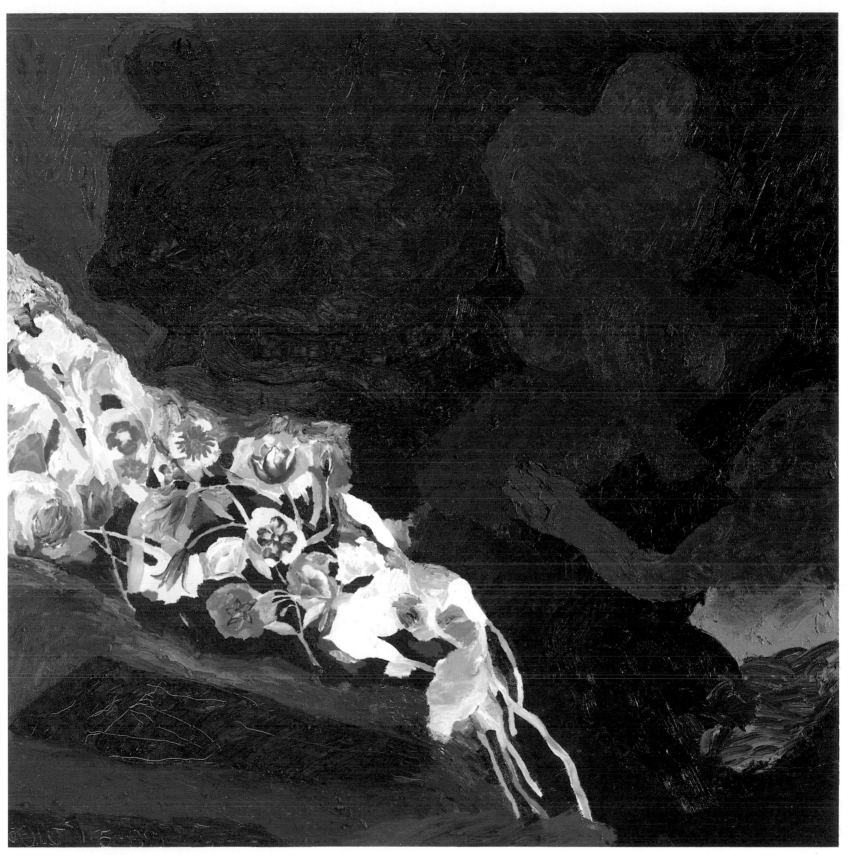

Untitled (1.5.88), 1988
Oil on linen
96½ x 96½ in.

Oliver Jackson

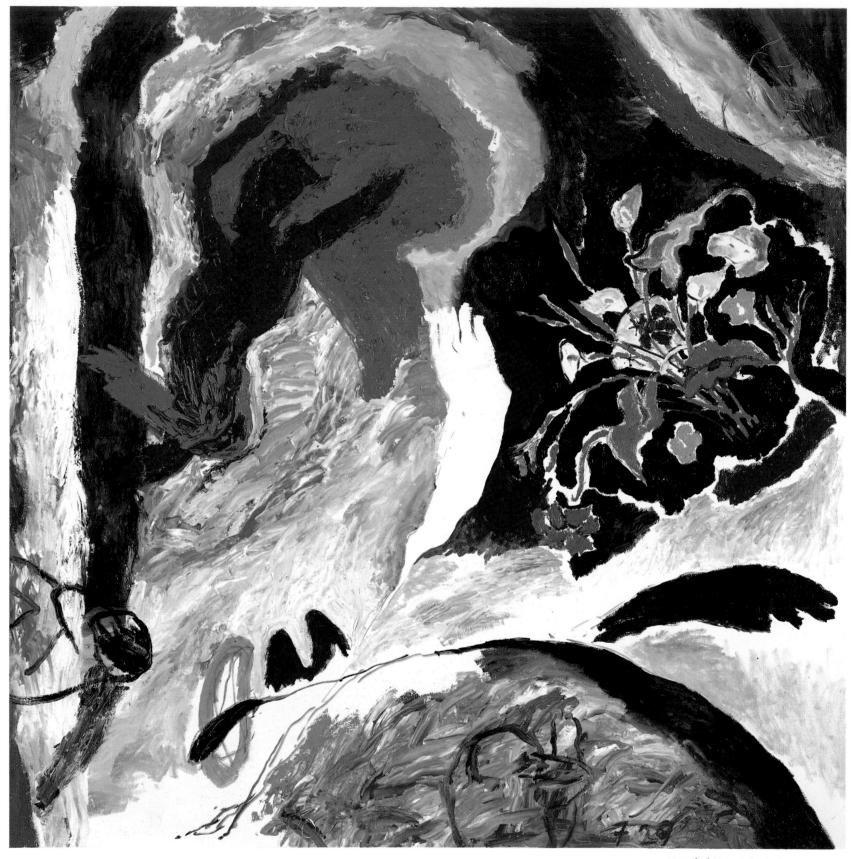

Untitled (7.29.86), 1986
Oil on linen
96 x 96 in.

Oliver Jackson

Richard Jackson

This society tends to produce and stockpile a lot of things that it doesn't need. If art can't change the way people think about something (at least about art), then who needs it? The making of art is selfish. The marketing of art is foolish. The art process should involve unusual behavior.

Painting with Two Balls, 1987–88
Acrylic on canvas and welded steel;
acrylic on two-sheet aluminum
Painting: 162 x 441 x 2 in.;
each ball: 60 in. diam.

Richard Jackson

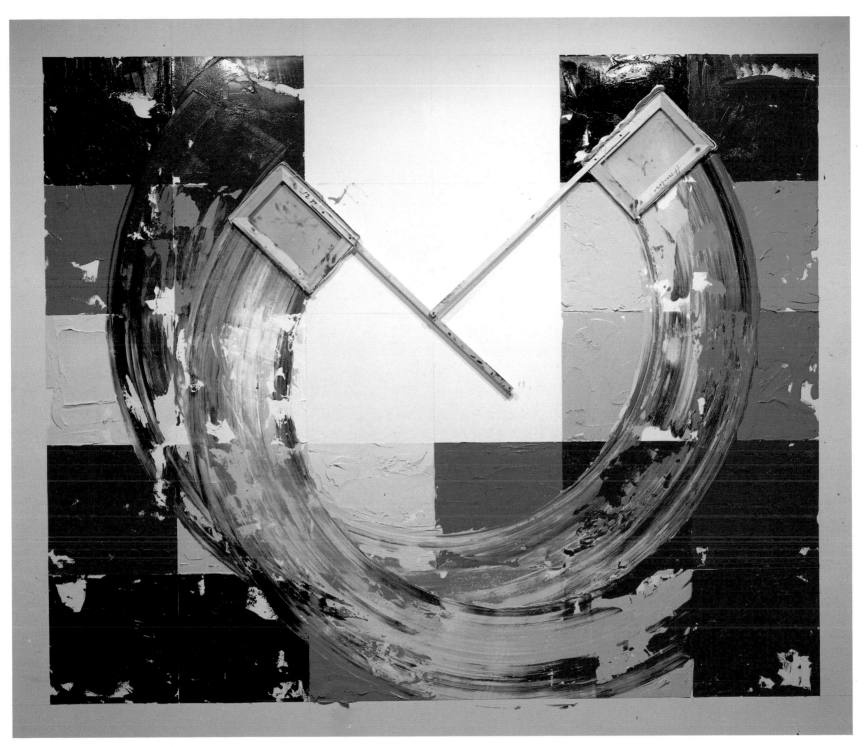

Oil, TX, 1988
Oil, canvas, and wood; painted on wall
132 x 132 in.

Richard Jackson

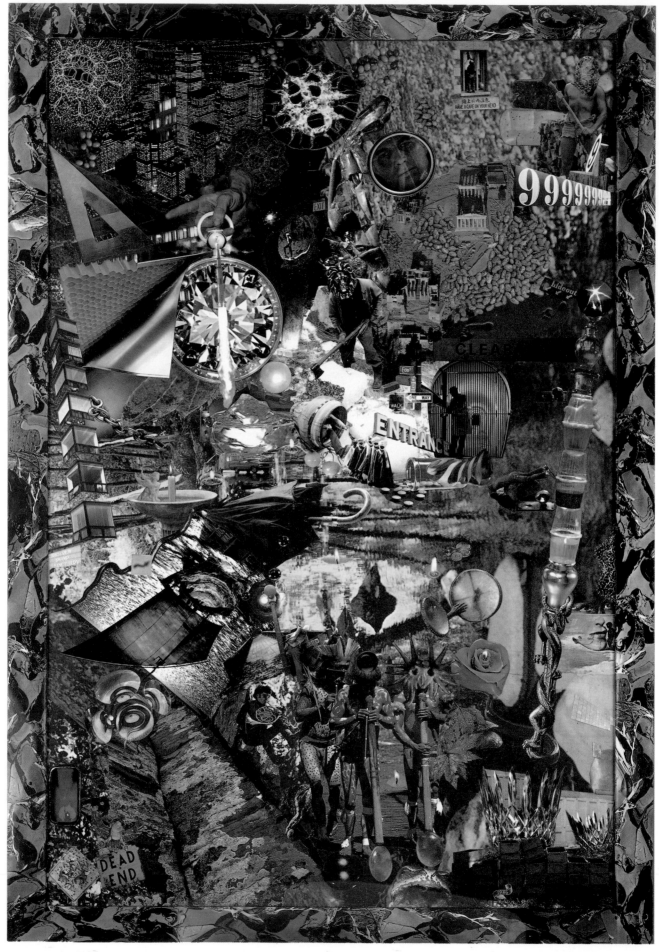

Jess

Hermit Tarot, 1987
Paste-up
39¾ x 27¼ in.

Jess

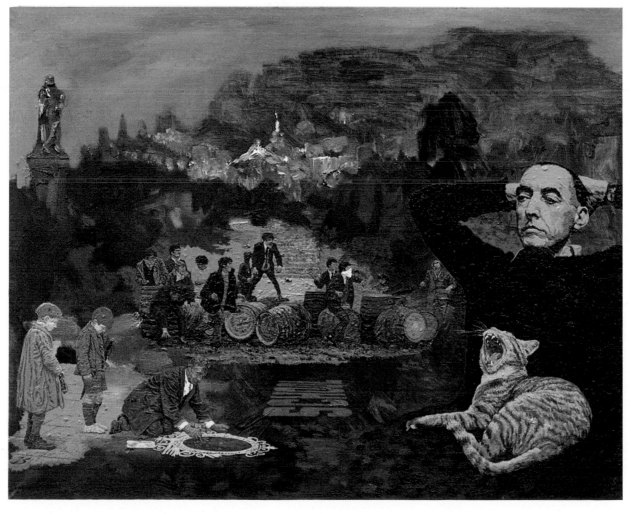

"Signd and Resignd," Salvage VII, 1987
Oil on canvas
17 x 20 in.

Mort and Marge, 1971
Translation #26
Oil on canvas over wood
20 x 30 in.

Jess

Craig Kauffman

Looking back over my career, the work I have produced seems to naturally organize itself into series. Between these series are transitional works that chart the changes from one series to the next. Although the series are relatively consistent, and quite consciously so, the transitional works are quite different from one another. Some are very interesting, others are not. In the past, with few exceptions, I have only exhibited the transitional pieces that relate specifically to the direction of my work. Often they have appeared to be extremely exaggerated.

I would like my work and its development to appear to be logical and coherent, but it is much more complicated than that. I have tried to give up fretting about this state of affairs and trying to make logical sense out of the whole thing. With this has come a loosening up of style and a dredging up of information from past series in an almost unconscious manner. I work much more quickly now, and try to get out of the way of what I'm about and to stop intellectualizing and agonizing over each move.

I live part of the year in Manila. The Philippines are a strange mixture of East and West, and I feel very much at home there. I have lived for extended periods in New York and Europe. Finally, the Pacific Rim is my orientation and my home.

Untitled, 1987
Acrylic on silk mounted on canvas
60 x 48 in.

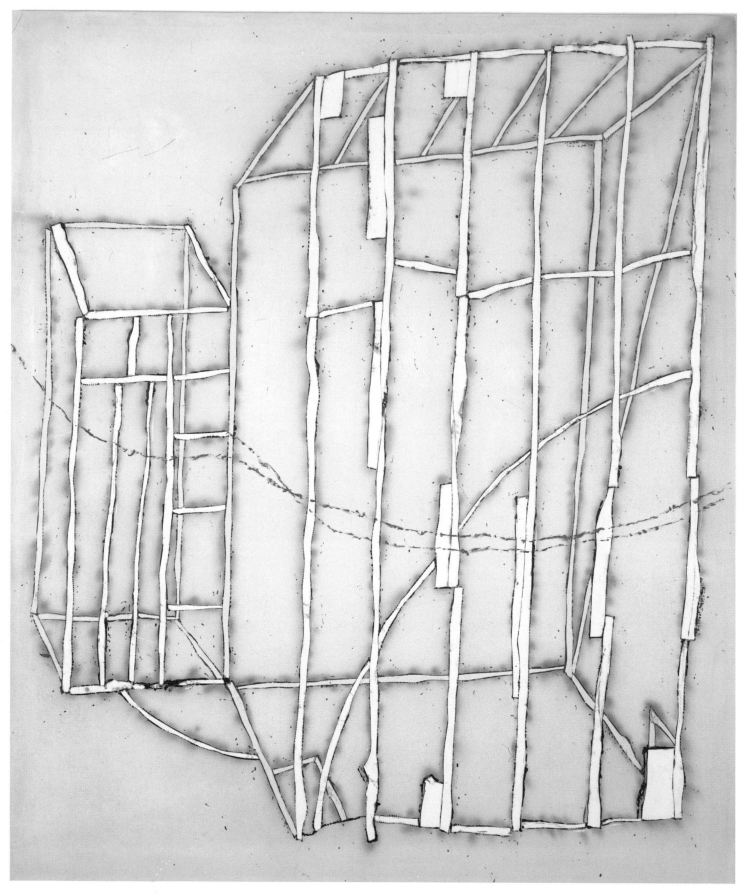

Untitled, 1988
Acrylic on silk
73 x 61 in.

Craig Kauffman

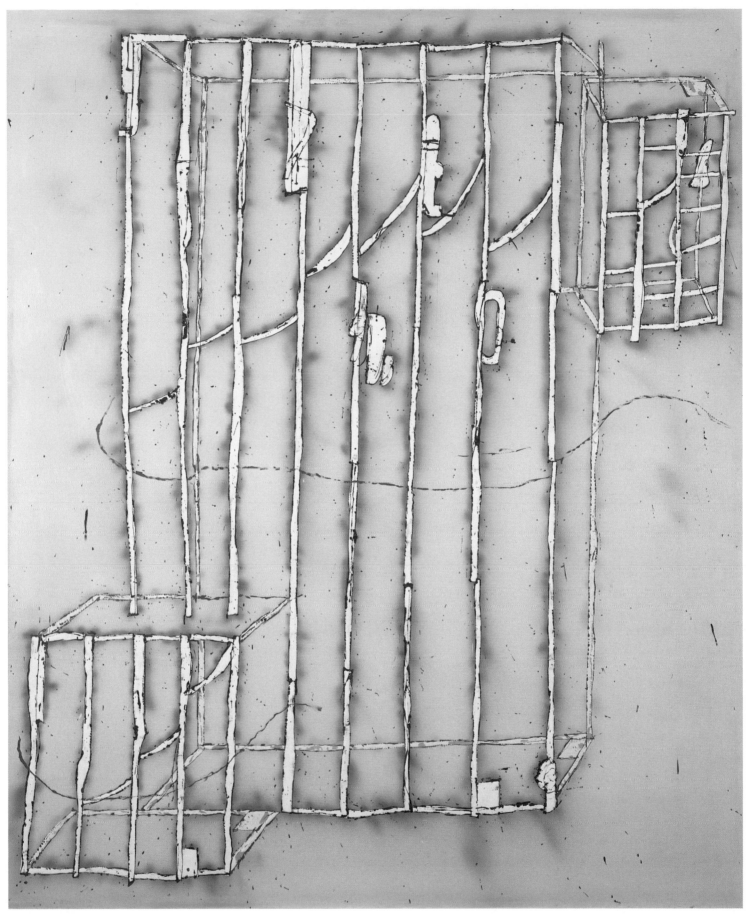

Untitled, 1987
Acrylic on silk
75½ x 63½ in.

Craig Kauffman

93

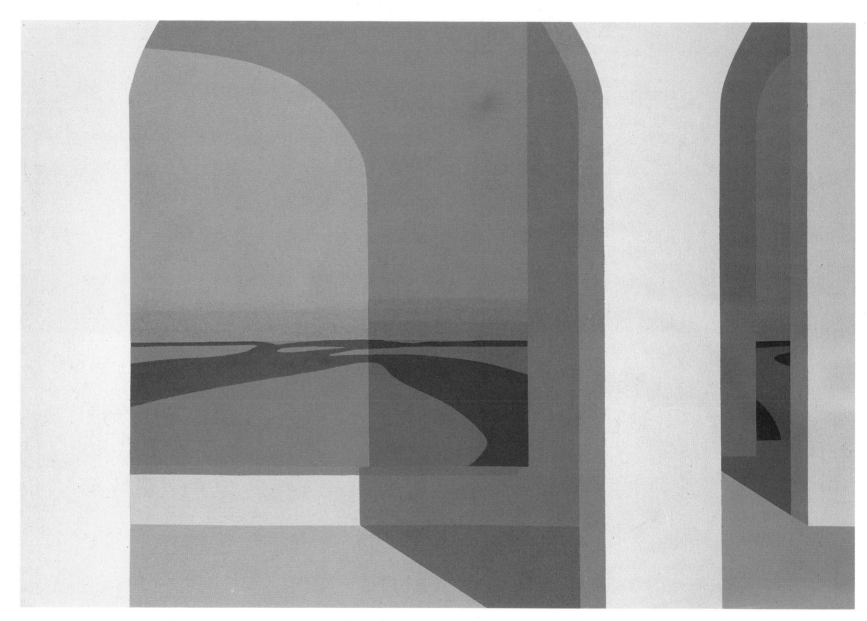

Earth Shadow Rising, 1984
Acrylic on canvas
35 x 50 in.

Helen Lundeberg

Helen Lundeberg

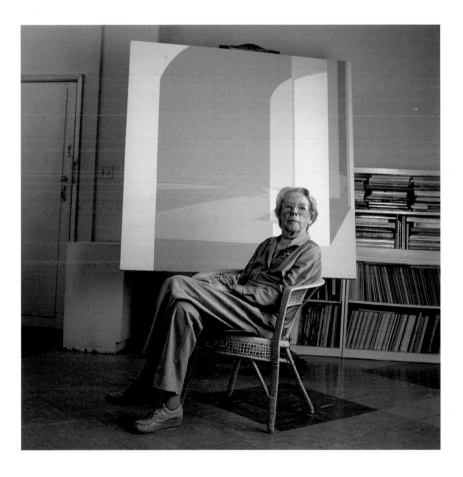

I am rather reluctant to make statements about my work: first, because I hope that it speaks for itself; second, because I think others have written about it better than I can. I have seldom felt misunderstood by critics, most of whom have recognized that my work is both lyrical and formal, and that these elements are inseparable and constant, however much paintings of various periods may differ in scale, palette, and images. The principles remain the same.

I have never been interested in pure nonobjective abstraction. I love too much the forms, perspectives, and atmosphere of our natural world. I have tried to represent them in many ways and in varying degrees of abstraction. Now, in the 1980s, I find myself turning more and more to landscape, but my landscapes, as always, are invented, as are the architectural fragments that sometimes accompany them or frame them, as in *Night Flying In*.

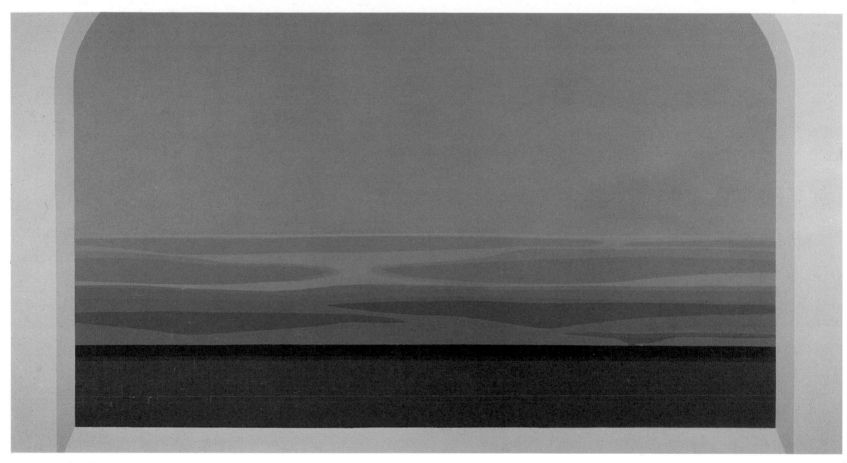

Night Flying In, 1984
Acrylic on canvas
36 x 72 in.

Helen Lundeberg

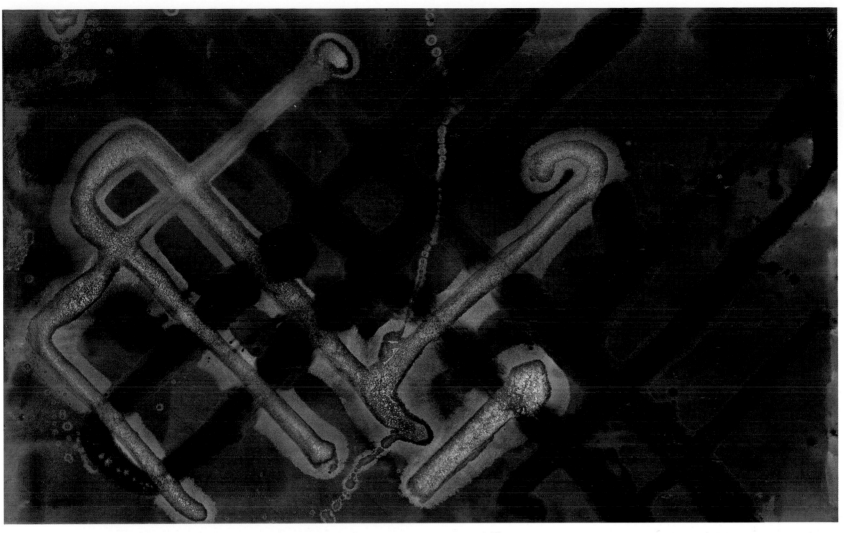

Blue Trac, 1987
Oil and acrylic on canvas
60 x 96 in.

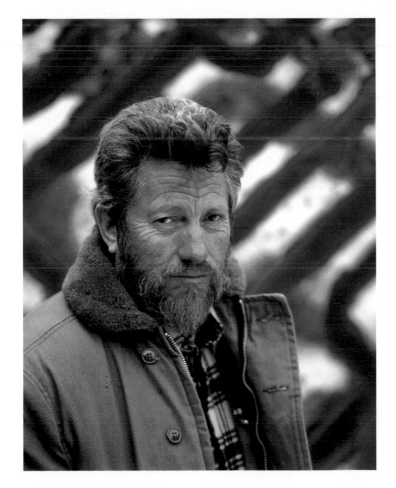

Ed Moses

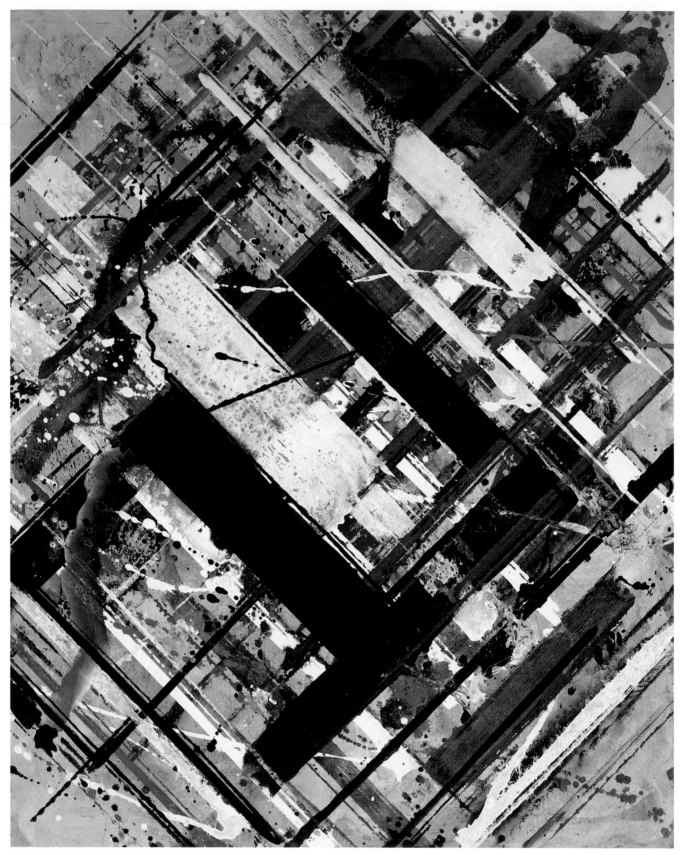

Untitled, 1986
Oil and acrylic on canvas
78 x 66 in.

Ed Moses

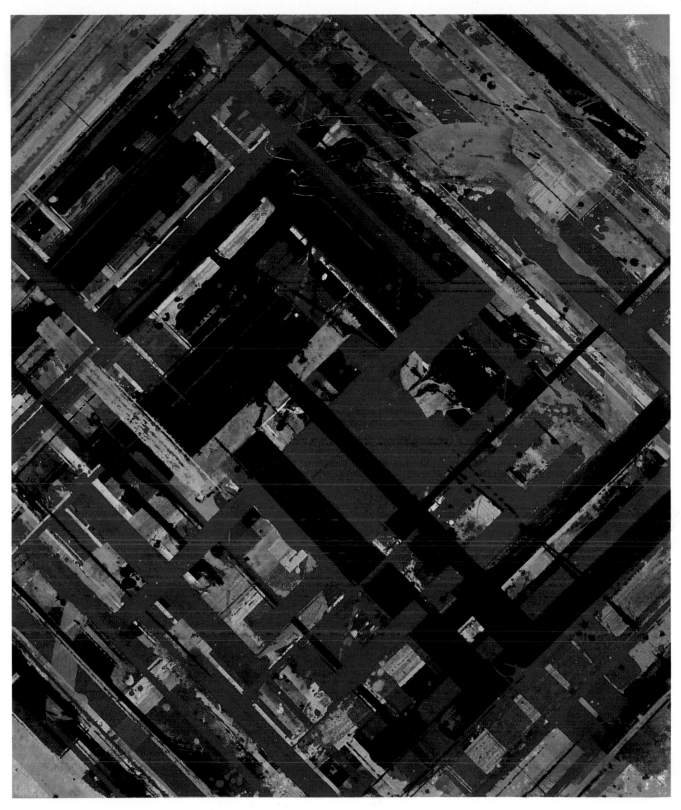

Untitled, 1987
Oil and acrylic on canvas
60¼ x 48 in.

Ed Moses

Lee Mullican

My life as a painter in California has kept me remarkably close to nature, to the West, the Southwest, the desert, mountains, clouds, ocean, and plain—all a part of the Pacific rhythms.

Painting continues to be a remarkable life-invigorating event. I now work in several different media. Drawing is basic; sculpture in wood assemblage, bronze, and ceramic are vital extensions. In more recent years I have been experimenting with computer graphics.

In painting I am still involved with the meditative surface. The paint may be thrown, spilled, marked with precision by knife or brush, but key elements remain: layers and actions that invoke a classic late-surrealist automatism. There are space relationships and transparencies that come from a belief in "The Possible," which help with my search for "Inner Space" and the "Spiritual." Recent paintings are dominated by drawing and precise brushwork. Abstraction is still the major event. Primitivism and the tribal are of vital concern. There are many uses of the head, body, and personage. These elements are seen as petroglyphic markings, iconic guardians, and calligraphic glyphs.

Expansions of spirit in painting are consistently occurring as space walks, tidal swings, and so on, coming from surprise and imagination found in daily studio concerns. The sun rises, the sun sets.

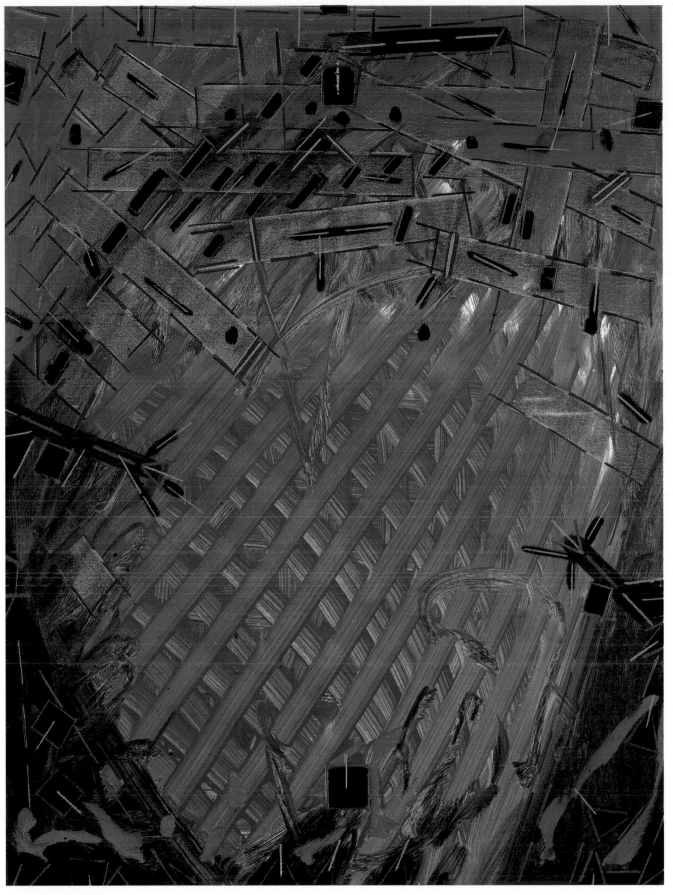

Break Awake, 1988
Oil and acrylic on canvas
40 x 30 in.

Lee Mullican

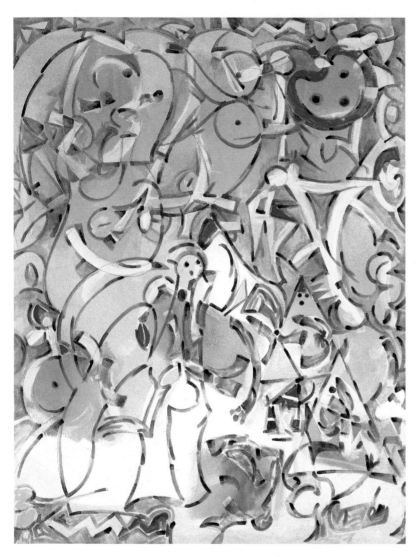

Picasso-Hide-Seek, 1988
Acrylic on canvas
50 x 40 in.

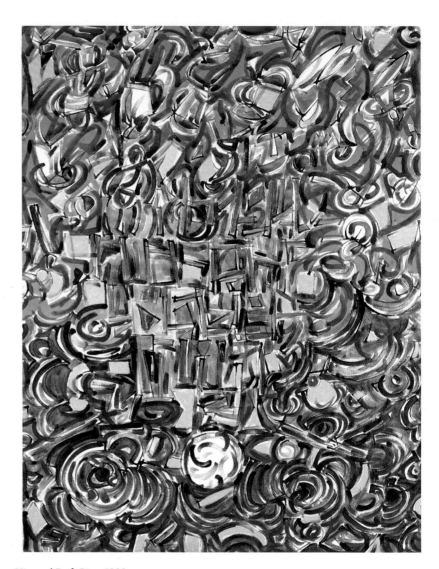

View of Red City, 1988
Acrylic on canvas
50 x 40 in.

Lee Mullican

Nathan
Oliveira

I relate to artists who have used oil paint gesturally as a plastic medium. In some ways time is negated, for one is always confronted by the actual performance and energy of one's visions. This play of material, and what one sees within it, is the substance of my engagements and my reason for working.

Model I, 1987
Oil on canvas
66 x 54 in.

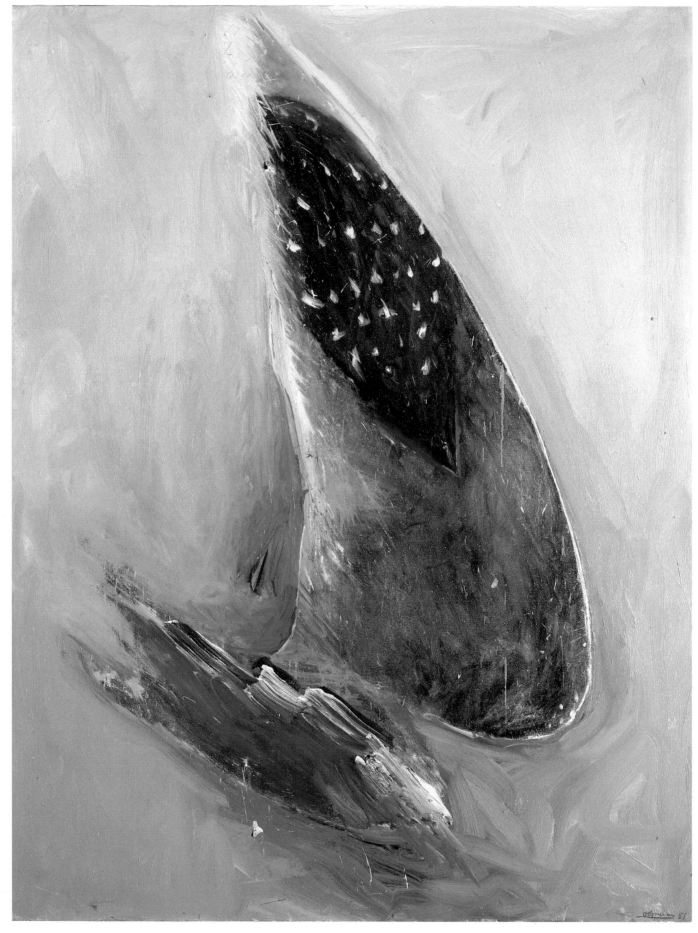

Wing III, 1987
Oil on canvas
84 x 63 in.

Nathan Oliveira

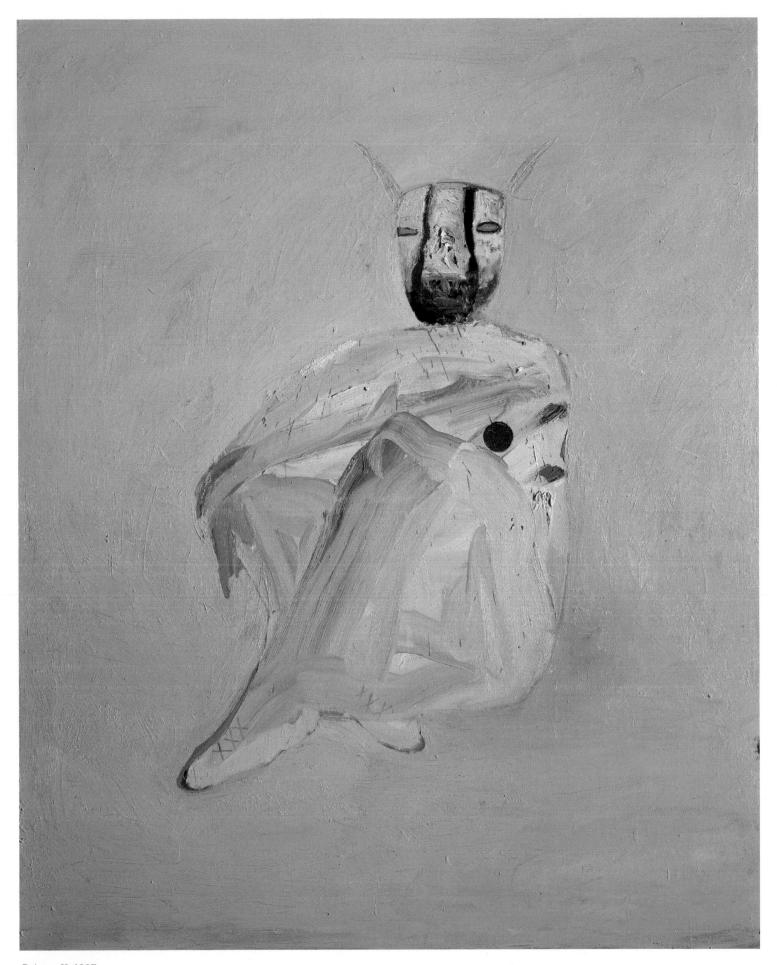

Painter II, 1987
Oil on canvas
84 x 67 in.

Nathan Oliveira

105

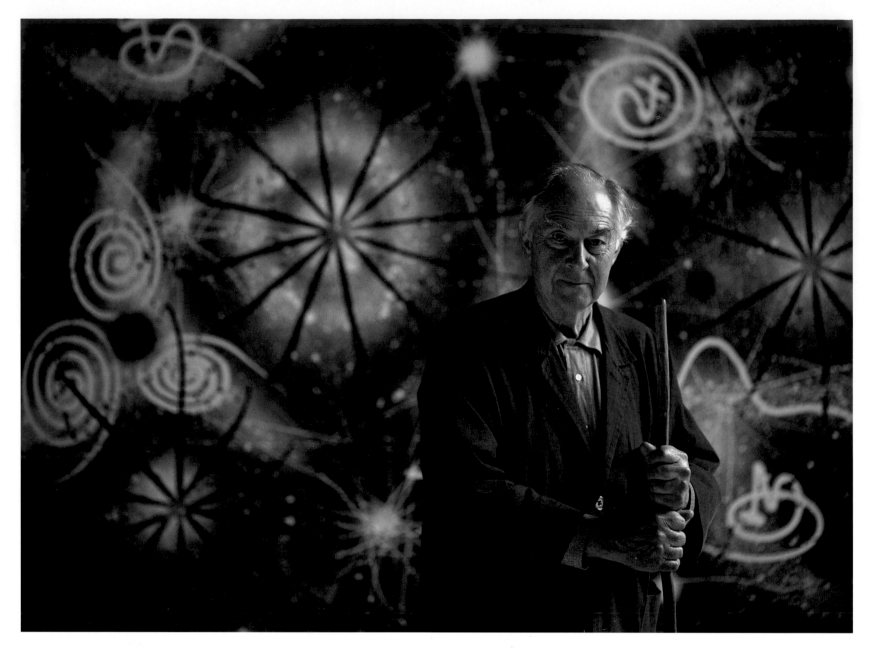

Gordon
Onslow Ford

Painting is my form of meditation. For a day to be bread I need to create something, to see anew. Throwing paint is always a surprise. Things happen that I could not do by myself. The stars shine, the trees branch out, the grass grows.

When I first made automatic drawings, though they did not resemble any known thing, I knew they were alive. To realize that there was another live world, invisible until it was expressed, was exhilarating. The experience of the invisible, intangible inner worlds starts in a small way. The never-seen-before appears casually in a corner and can easily slip away unseen. But if you are paying attention, before you know it, there is another never-seen-before. The inner worlds are entered through the contemplation of the never-seen-before.

An inner world painting comes into being directly from the inner worlds of the mind onto the canvas through the painter as an instrument. Modern artists have been through an experimental stage. We are now expressing ourselves from within; inner earth is playing with outer earth. I believe the art of our age is only just beginning.

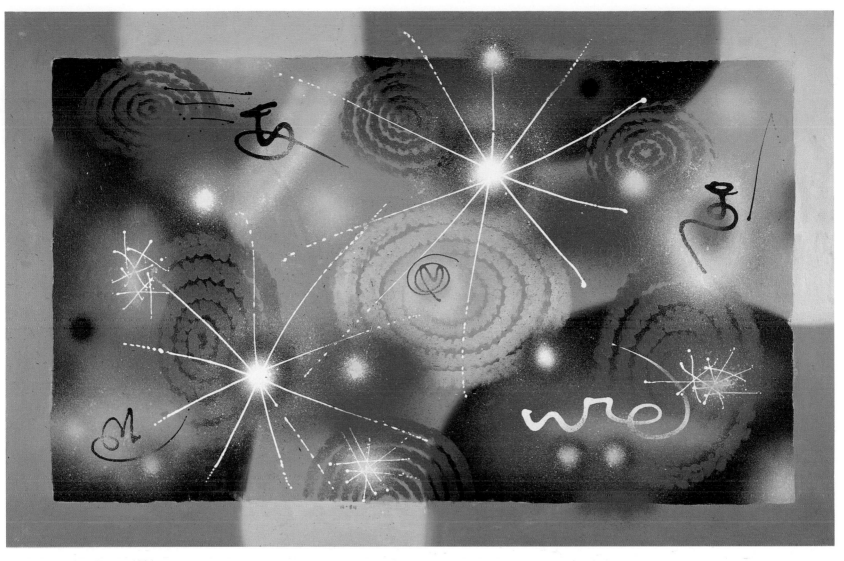

One Dance, 1984
Acrylic on canvas
74 x 116 in.

Finding the Child, 1986
Acrylic on canvas
35 x 54 in.

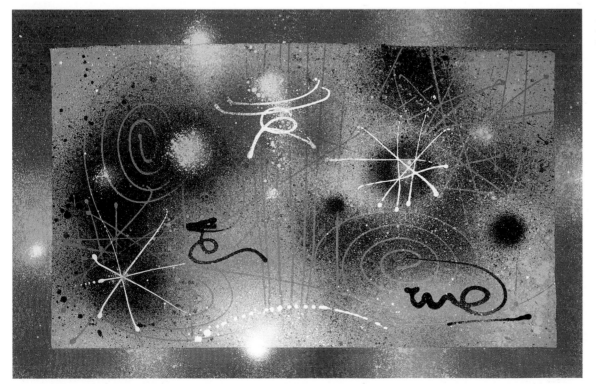

Gordon Onslow
Ford

107

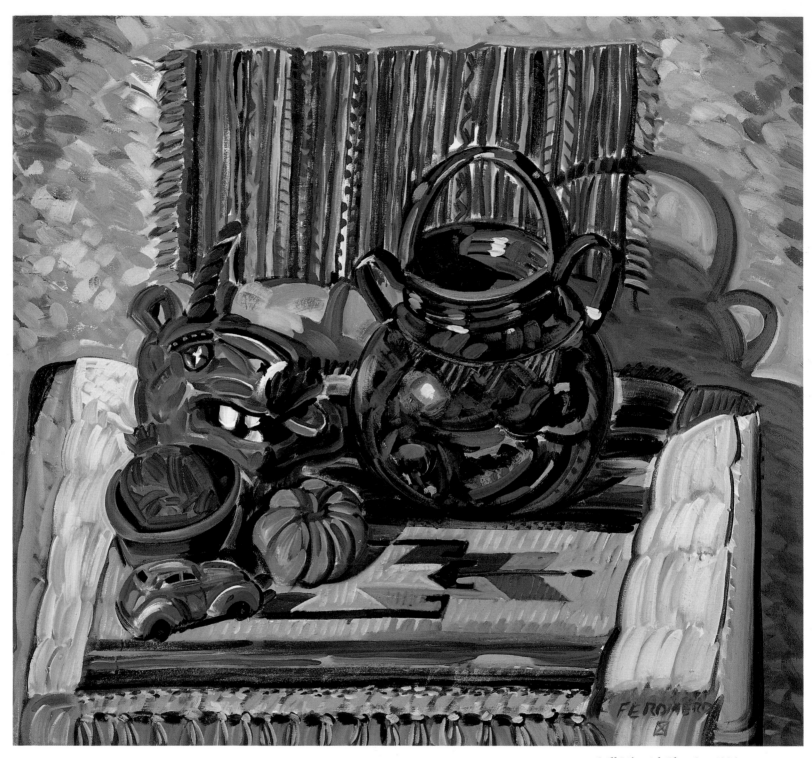

Still Life with Blue Car, 1986
Oil on canvas
48 x 50 in.

Frank Romero

Frank Romero

My work is about the things I like and the things I enjoy doing. It is about color, the application of paint, the way things feel. It's about being Hispanic and living as an artist in Taos, Los Angeles, and Mexico.

Folk art, heroic scale, Edward Hopper, George Catlin, public art, the great theme of transportation, and heroic women are all concerns of mine.

My art is about life in the present and about living in a continuum where past concerns must be reinterpreted in new ways.

My art is about having fun.

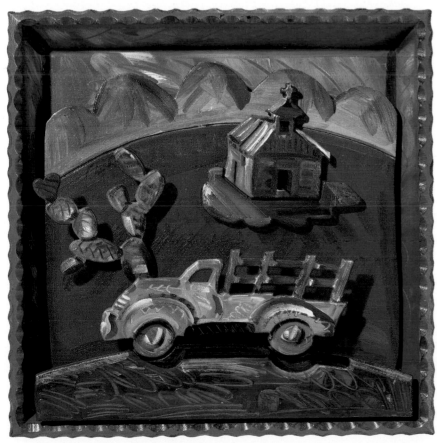

The Middle Road, 1988
Oil on wood
22 x 22 x 4 in.

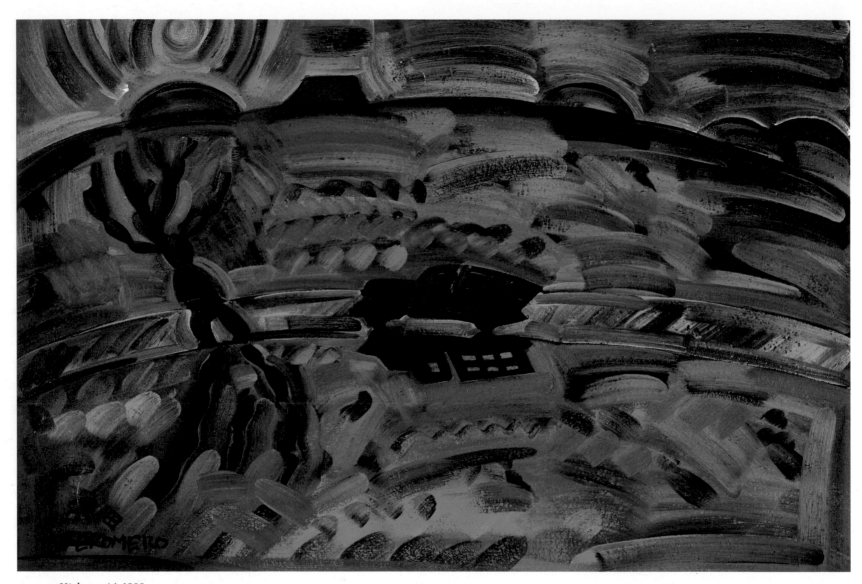

Highway 64, 1988
Oil on canvas
24 x 36 in.

Frank Romero

110

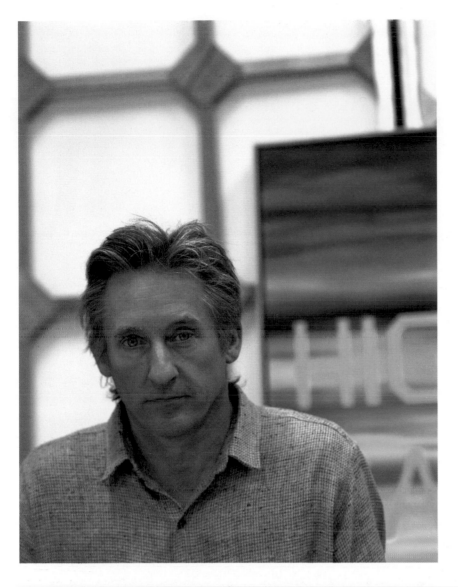

Edward Ruscha

No matter what style an artist works within, he is still a little soldier to art history. If he were born fifty years earlier, he wouldn't do the same things he does today. Artists are so vulnerable that, despite a tough exterior, they are influenced by trivia they would otherwise consciously reject. But a visual artist has the right never to be questioned about what he does. Isn't this what they call "artistic license?"

Most artists are doing basically the same thing—staying off the streets. I don't feel like I am committed to any kind of heroic study. I committed myself to being an artist, and I've done it for twenty-five years. It's daily routine.

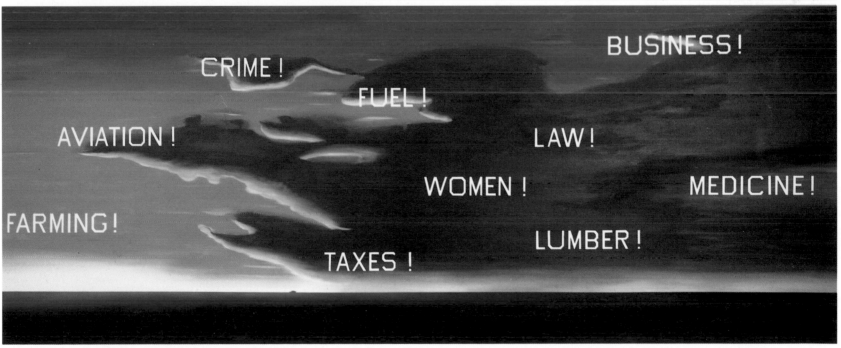

20th Century, 1987–88
Oil on canvas
59 x 145½ in.

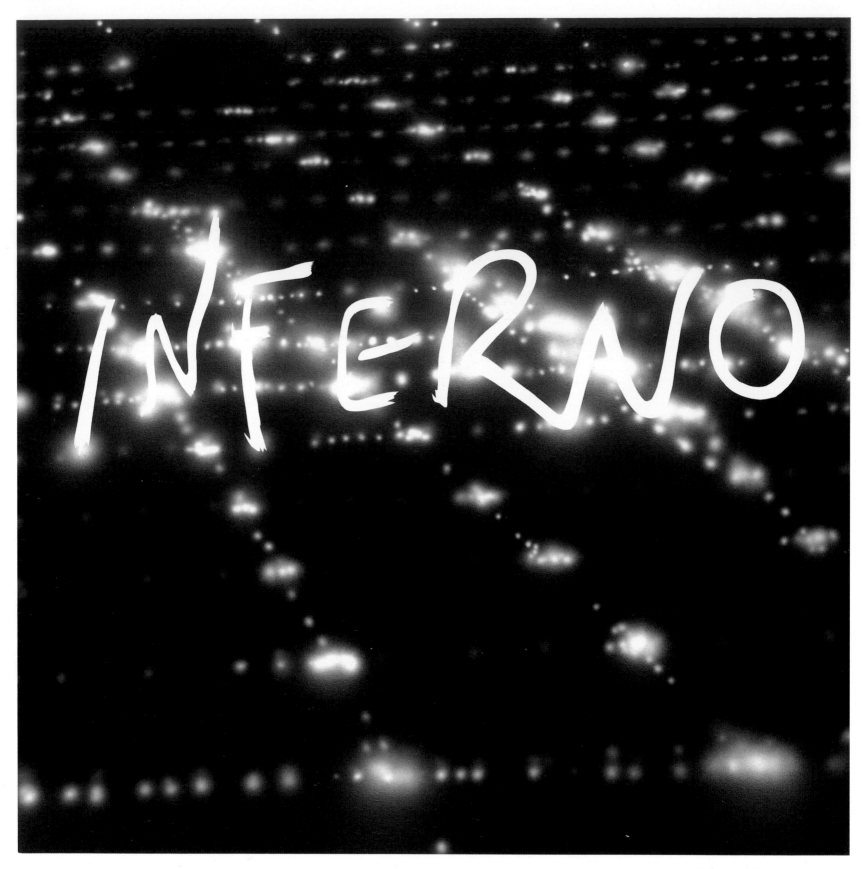

Inferno, 1987
Acrylic on canvas
72 x 72 in.

Edward Ruscha

You and Your Neighbors, 1987
Acrylic on canvas
54 x 120 in.

A Girl I Walked All Over, 1988
Acrylic and varnish on canvas
60 x 84 in.

Edward Ruscha

113

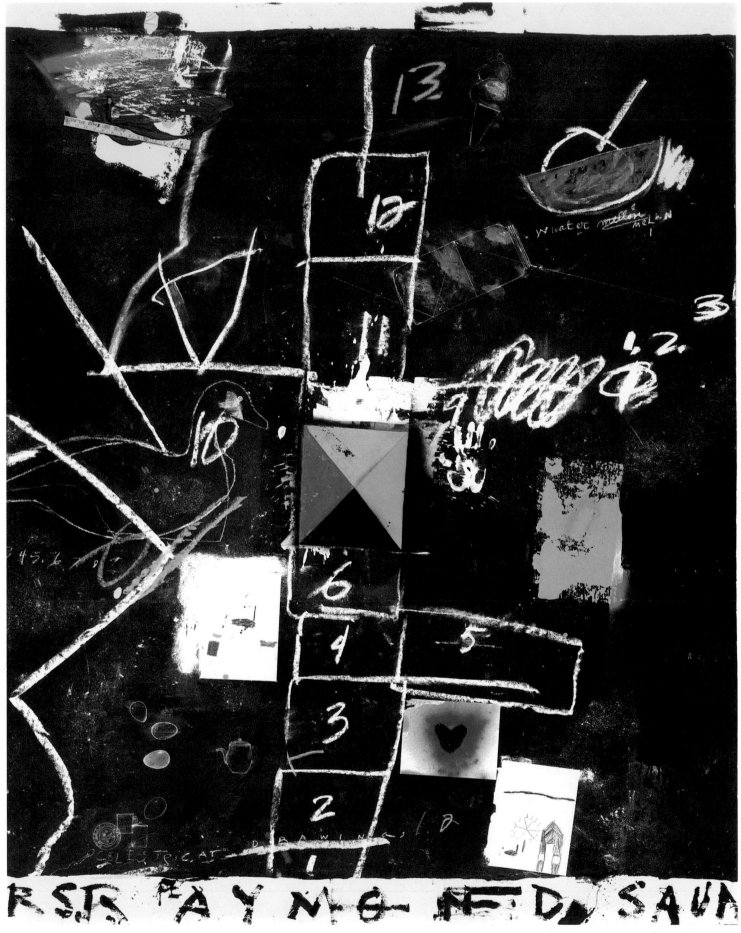

Celeste Age 5 Invited Me To Tea, 1986
Mixed-media on canvas
104½ x 83¼ in.

**Raymond
Saunders**

Raymond Saunders

You want mc to talk about art? I'll have to ask Brenda.

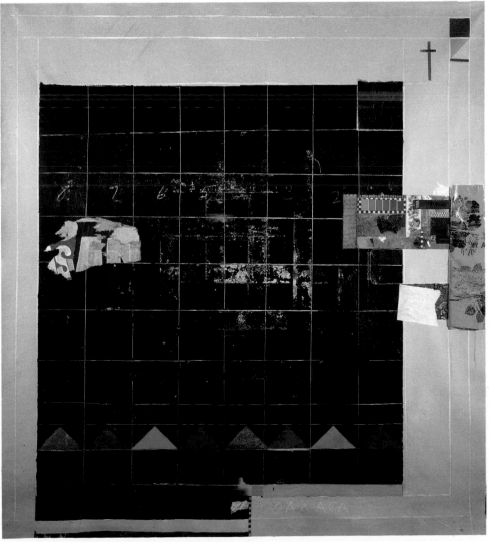

Still Life Mixed In With Other Voices, 1988
Mixed-media and oil on canvas
94 x 84 in.

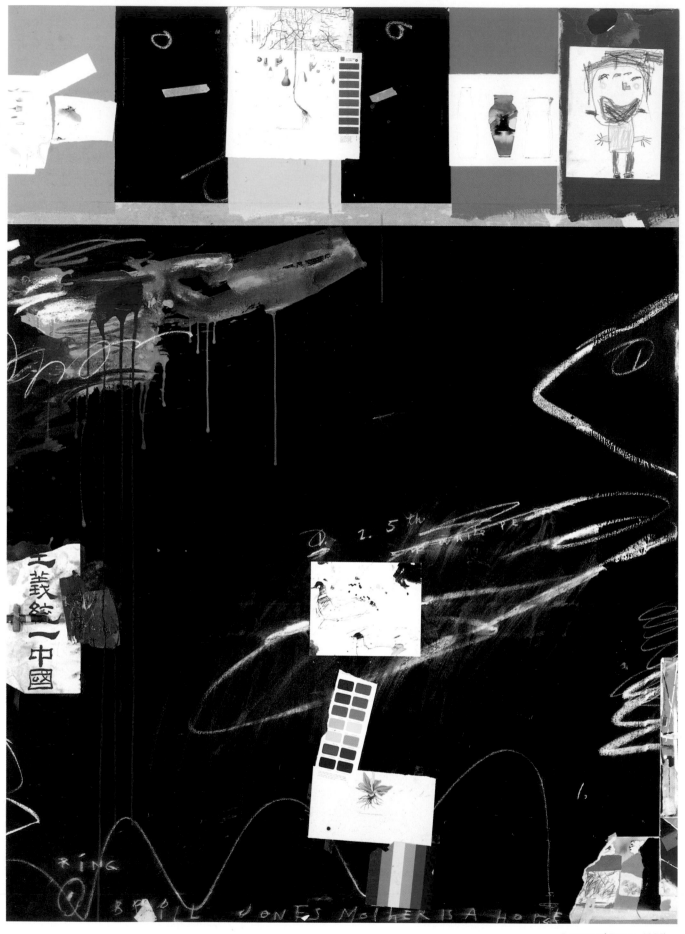

Layers of Being, 1985
Mixed-media on canvas
80 x 60 in.

Raymond
Saunders

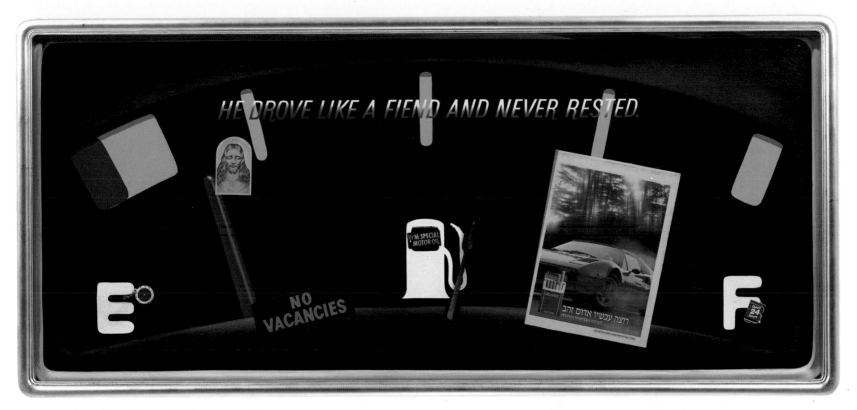

Running on Empty, 1988
Mixed-media collage
34½ x 74⁷⁄₁₆ in.

Alexis Smith

I don't feel as comfortable expressing myself in writing as I do through the medium of art. For me, visual art, and collage in particular, has the greatest potential for capturing the paradoxical quality of life and for communicating its subtle complexities. There's a familiar and seemingly universal resonance that I often find in other people's words and in everyday objects. I look at these familiar things from the real world and I see in them a commonality of thought and impulse and imagination. They are the only raw materials that entice me. They suggest a wealth of associations, metaphors, and whimsical juxtapositions that finally motivate me to art making . . . that fascinating, self-conscious playground for adults.

Mercury, 1987
Mixed-media collage
2 panels: 43¾ x 36⅝ in. each

Alexis Smith

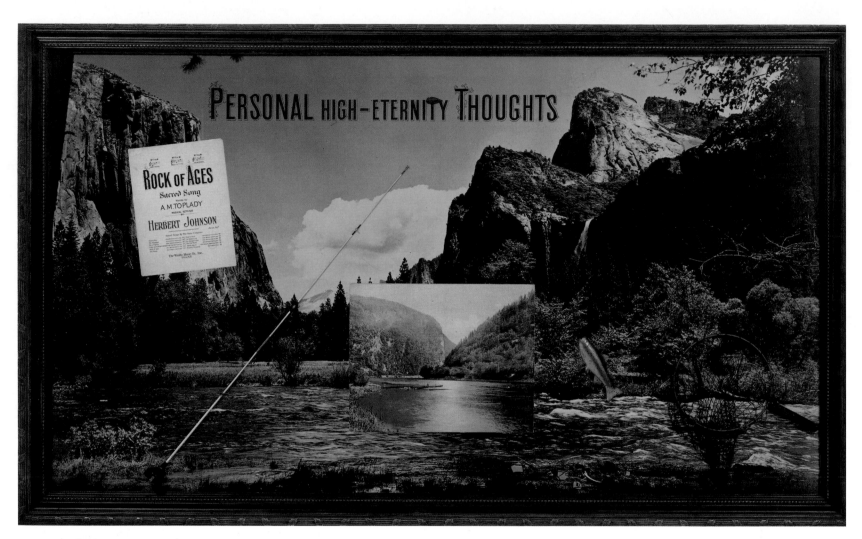

Rock of Ages, 1988
Mixed-media collage
54¼ x 90⁵⁄₁₆ in.

Alexis Smith

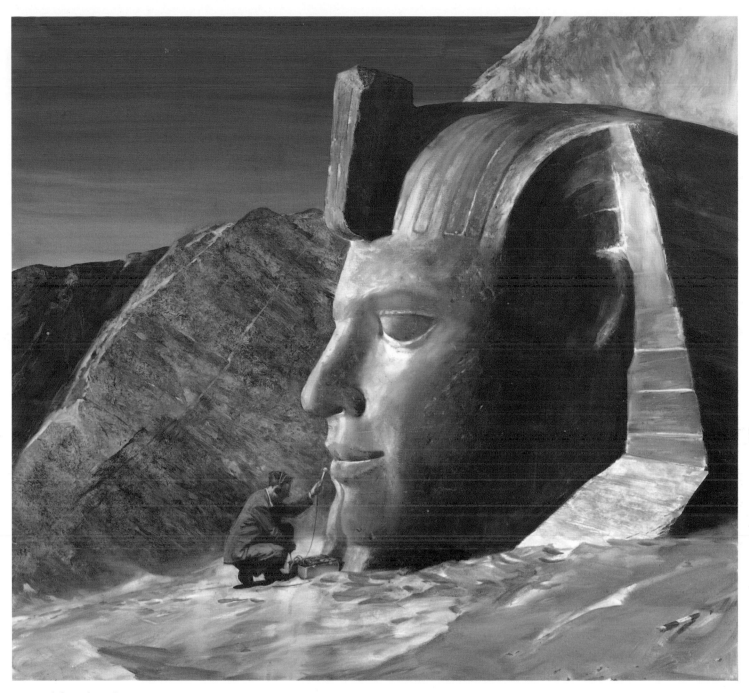

Secret of the Sphinx (Homage to Elihu Vedder), 1984
Oil on canavs
60 x 65 in.

Mark Tansey

A painted picture is a vehicle. One can sit in the driveway and take it apart, or one can get in it and go somewhere.

The Bricoleur's Daughter, 1987
Oil on canvas
70 x 68 in.

Mark Tansey

Mont Sainte-Victoire, 1987
Oil on canvas
100 x 155 in.

Mark Tansey

Masami Teraoka

AIDS Series / Samurai Twist, 1988
Watercolor on paper
22¼ x 15 in.

The basis of my work, the humor and seriousness of two cultures—East and West—clashing, is provided by my own life experiences. In my paintings I highlight the contrasts between my childhood during the deprived war years in Japan, and my adulthood in the mass-consuming US of A. This basic contrast is played out in many ways. Consumption is not only physical, but also mental. I am continually amazed at the things that Americans think about. I feel that I have transplanted myself into very fertile soil and that my art has grown accordingly.

In my work I take the best and the worst of both cultures and juxtapose them in a coherent statement that is visually exhilarating. I use the visual language of the Japanese ukiyo-e print, which serves the dual purpose of expressing my roots and being an aesthetic vehicle for my statement. This allows me to use both the subtlety of Japanese art and the dynamism of its American counterpart. While I typically focus on social and environmental issues such as AIDS, pollution, and Toxic Shock Syndrome, lately I have added more pure landscapes to my repertoire. While these landscapes and seascapes are deceptively straightforward, they are also urgent statements. I feel that by presenting nature as beautiful as it is, perhaps we will understand how important nature is to us and realize that we must preserve it.

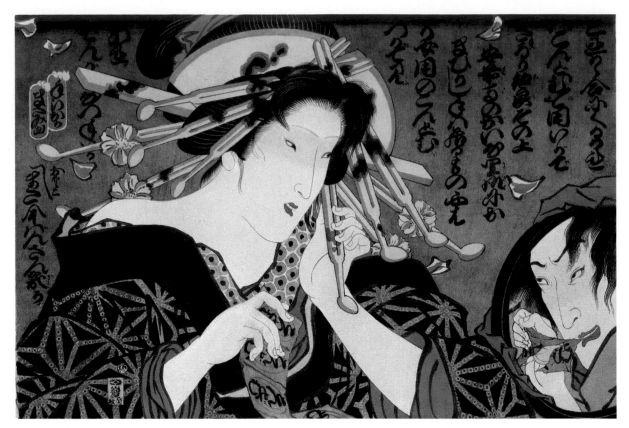

AIDS Series/Oiran and Mirror, 1988
Watercolor on paper
15 x 22¼ in.

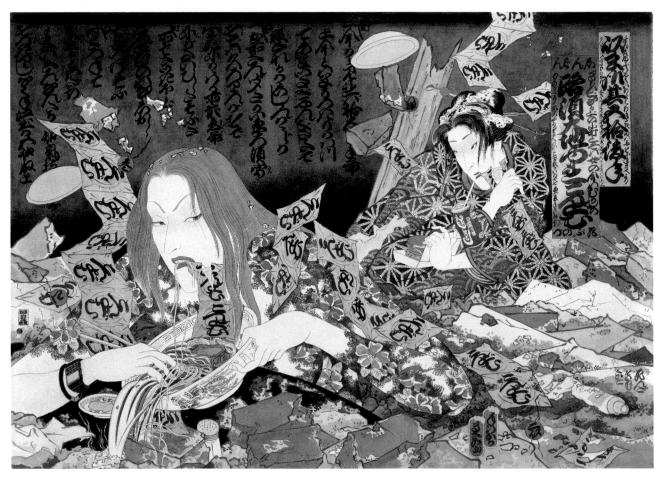

*AIDS Series/Tattooed Woman and
Flying Saucers*, 1988
Watercolor on paper
29½ x 41¼ in.

Masami Teraoka

126

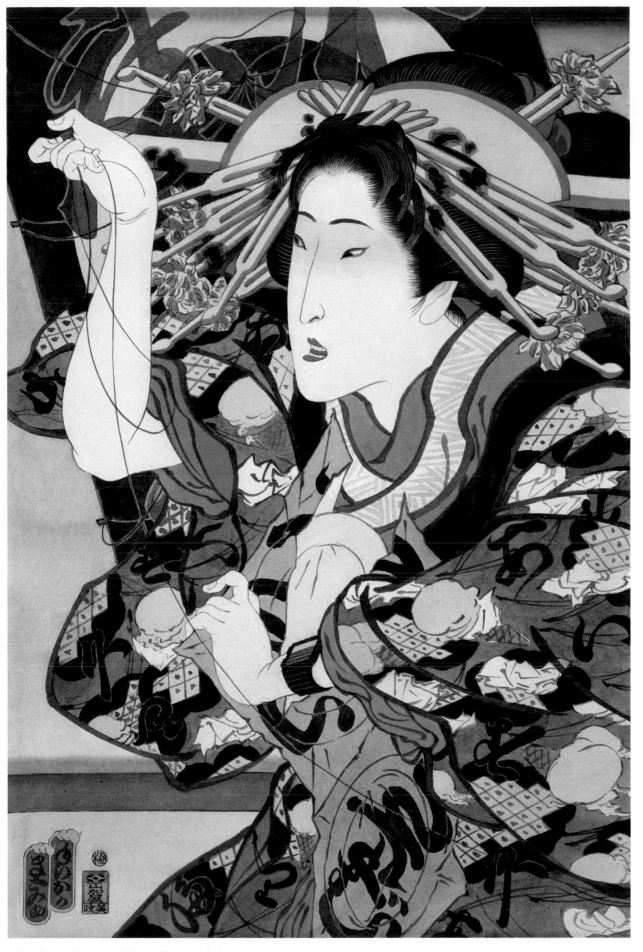

AIDS Series/Oiran and Kite, 1988
Watercolor on paper
22¼ x 15 in.

Masami Teraoka

127

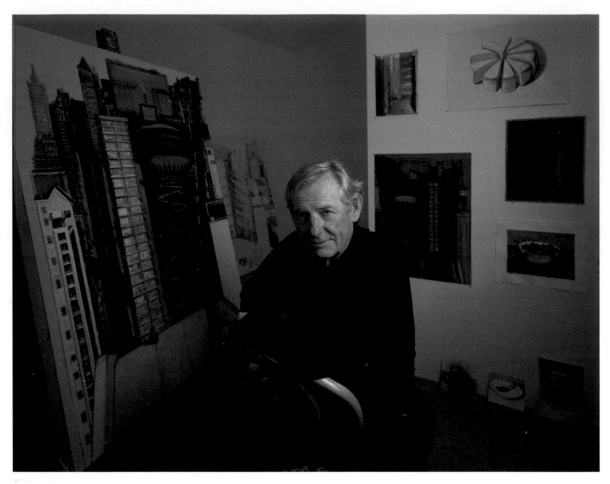

Wayne Thiebaud

At the end of 1959 or so I began to be interested in a formal approach to composition. I'd been painting gumball machines, windows, counters, and at that point began to rework paintings into much more clearly identified objects. I tried to see if I could get an object to sit on a plane and really be very clear about it. I picked things like pies and cakes—things based upon simple shapes like triangles and circles—and tried to orchestrate them. Working from memory, I tried to arrange them in the same way that an art director arranges things. I wasn't that different from an art director except that I had more time, and I tried to be more careful, tried to be more refined and interesting in terms of relationships. My approach was very formalistic, except that I became increasingly affected by the idea of this odd subject matter. I didn't quite know why, but it seemed to me that there are certain objects

that contain telltale evidence of what we're about as a people or as a society. But I wasn't interested in trying to explain or give answers so much as trying to present these objects so that they might be evocative in an existential sense. I tried to figure out why the object attracted me. A neutral description with a minimum of interpretation. I wanted to present it as directly as I could. A mimetic look after the object. The interesting problem with realism was that it seemed alternately the most magical alchemy on the one hand, and on the other the most abstract construct intellectually. Somehow the two had to merge. You can't depend, for instance, on a singular view of an object, at least I didn't feel I could, to dignify its presence or make it manifestly important unless it does something other than be a kind of replication, or simple visual recording.

From *Art of the Real: Nine American Figurative Painters*

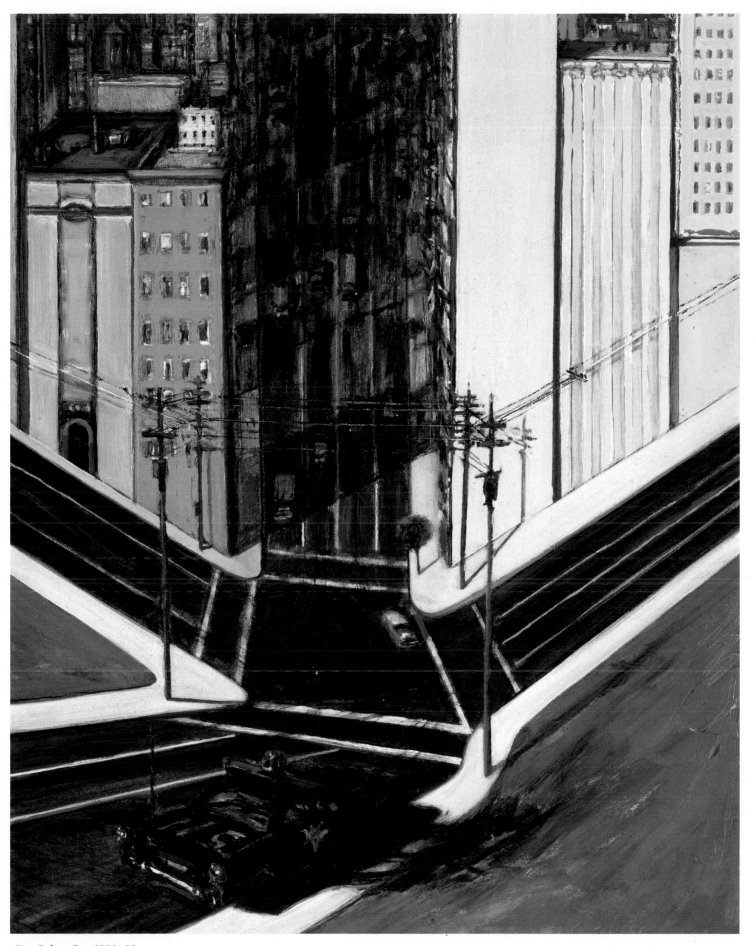

City Police Car, 1986–88
Oil on canvas
36 x 24 in.

Wayne Thiebaud

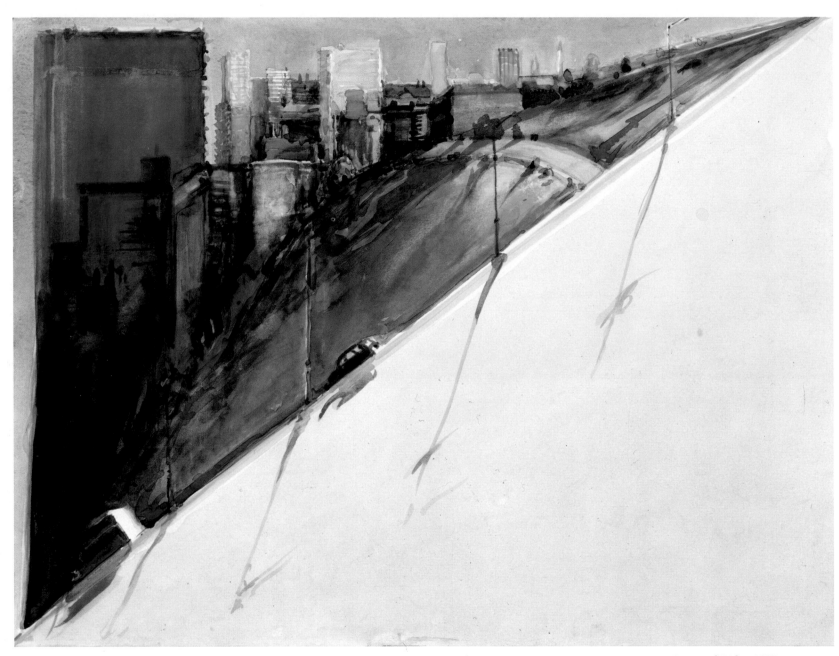

Diagonal Ridge, 1987
Watercolor on paper
8½ x 11 in.

Wayne Thiebaud

Joyce Treiman

I have been painting for as long as I can remember, and it is as marvelous to me now as it was in the beginning.

I love being a painter, I love paint as my medium, and I am glad that I realized early that *ars longa, vita brevis*. I just keep on discovering.

To make connections in my art with ideas, with great art that has been done, with myth: that is my challenge and what I have tried to cope with. Skills are a given, and having them leaves all the room for the enigma, mystery, and unexpectedness that should be in a wonderful painting. To me each painting is singular and special, and if it is *really good*, unforgettable.

If I can in my lifetime do ten great paintings, then I can be judged and I will feel I have not cheated myself.

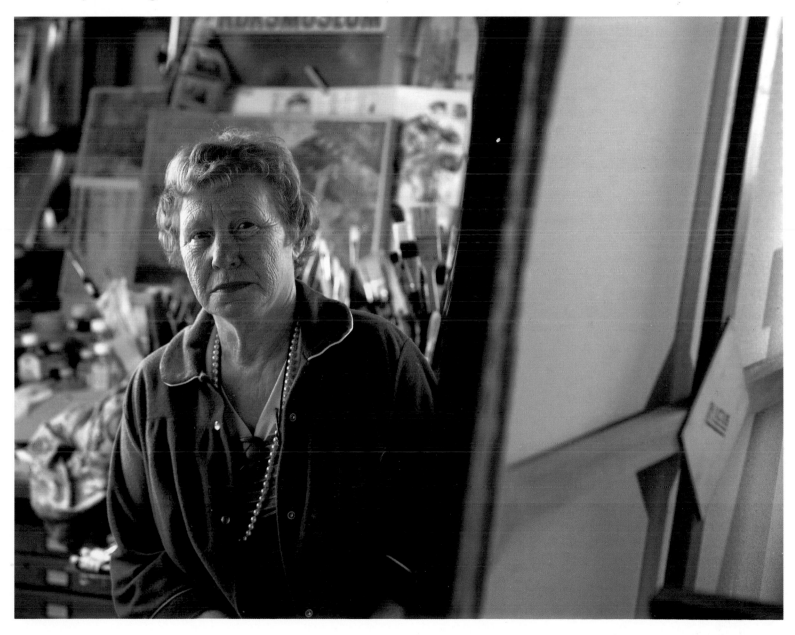

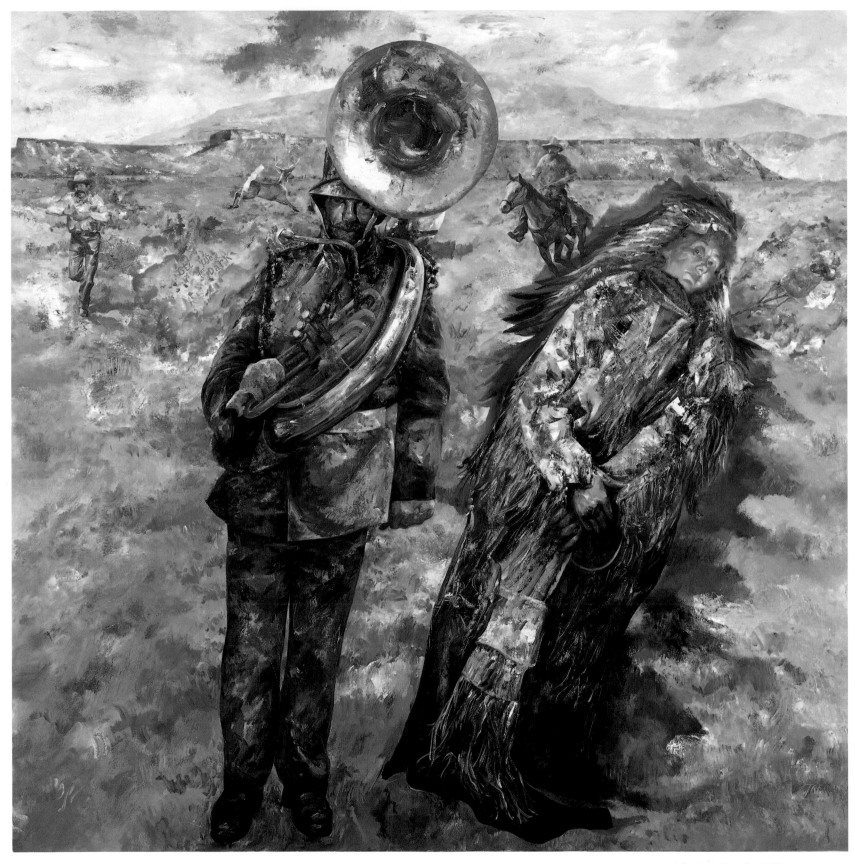

The Last Parade, 1987
Oil on canvas
70 x 70 in.

Joyce Treiman

132

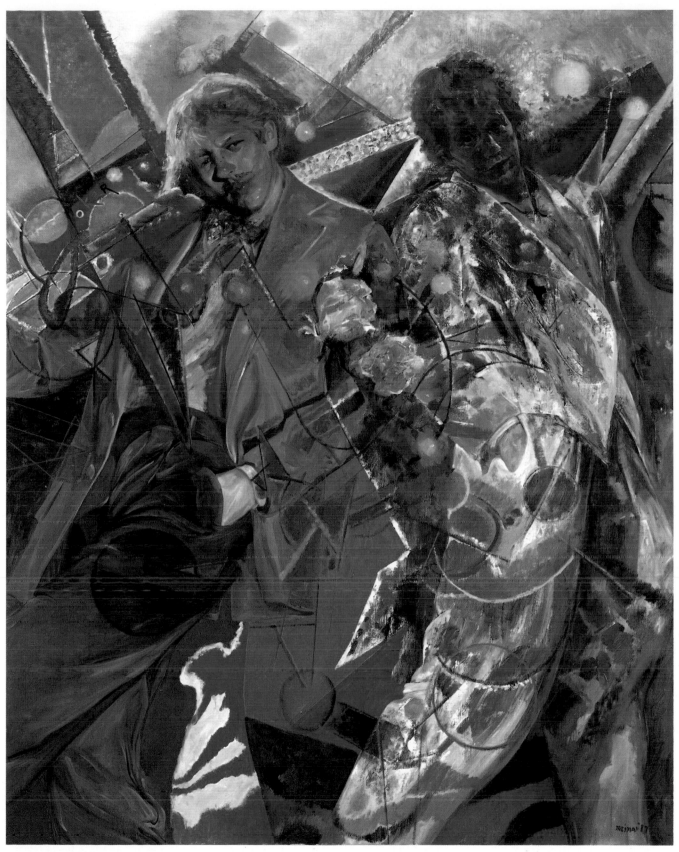

Joker, Me, and Geometry, 1987
Oil on canvas
50 x 40 in.

Joyce Treiman

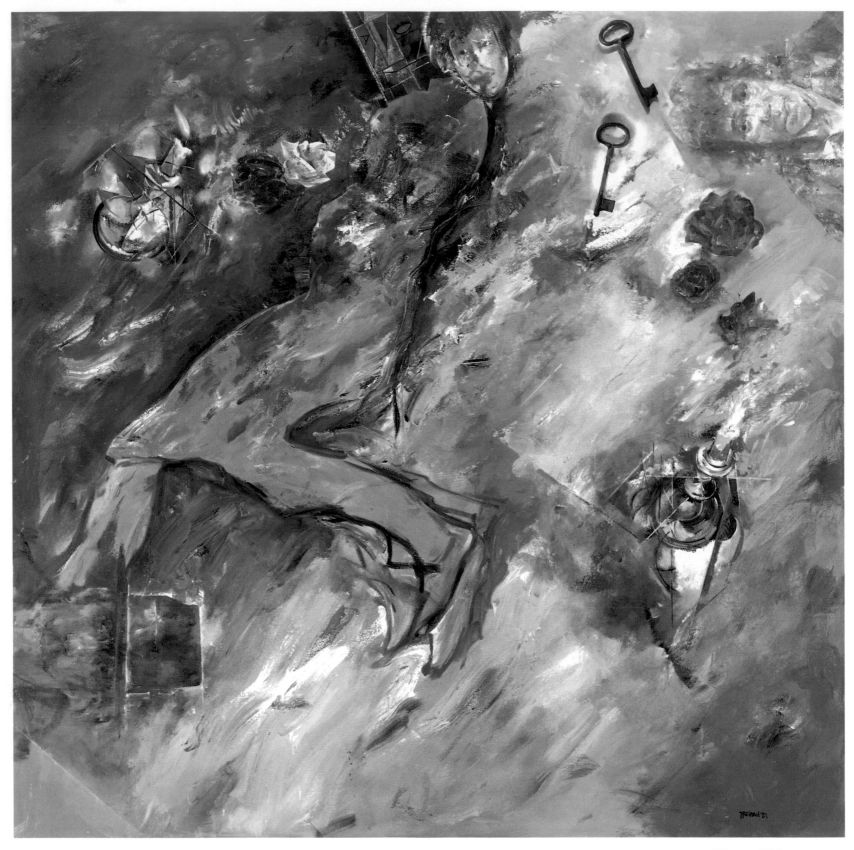

Witness, 1988
Oil on canvas
70 x 70 in.

Joyce Treiman

134

Emerson Woelffer

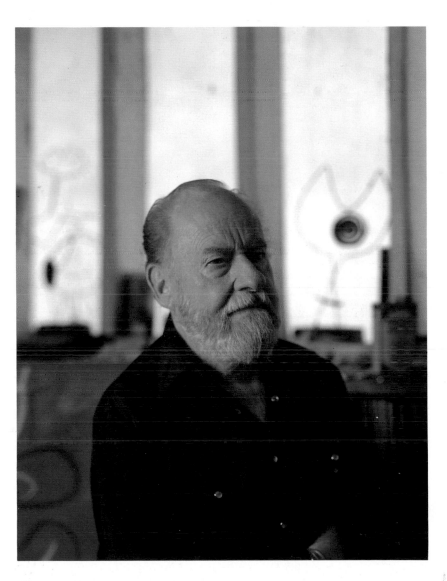

I first create a world of void, a total color space of red, blue, black—whatever is at hand. Then the action takes place, without any preliminary ideas or sketches. I do not know where I am going or where I have been until I stop. If I could picture it before the act of putting it down on paper or canvas, then why should I do it? I see it first after it is put down.

I am provoked in many ways: by my state of being; by chance, silence, the unknown; by chaos, order, night, day; by poetry, music, automatism.

Regardless of when a work of art was created—in the sixteenth century, the nineteenth century, 1940, or 1970—if it was good when it was produced, it will be good and live in any period. Of course, many works today are created with no interest in aesthetics or quality, but only to provide information of some sort. I have found myself bringing out work of several years past and changing or deleting areas, or completely destroying it. Destroying can also be improving, if that is the word, a creation out of chaos.

We all have our relatives of the past, and for me and for any good artist today there have been great ones: Matisse, Picasso, Miro, Seurat, Pollock, van Gogh, Masson, Arp, Man Ray, Picabia.

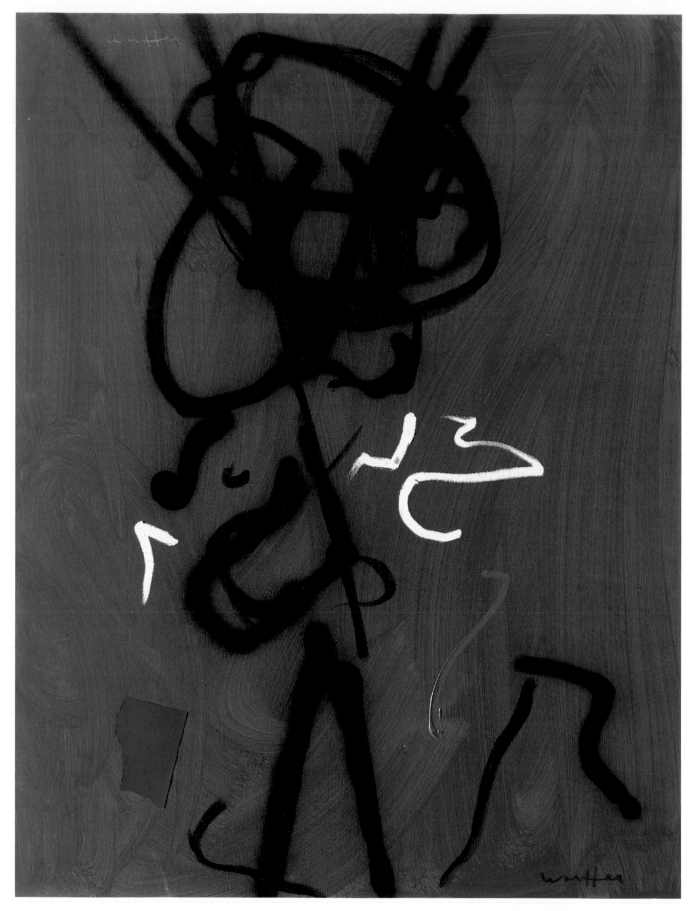

Eros, 1987
Oil, acrylic, and collage on canvas
46 x 35 in.

Emerson Woelffer

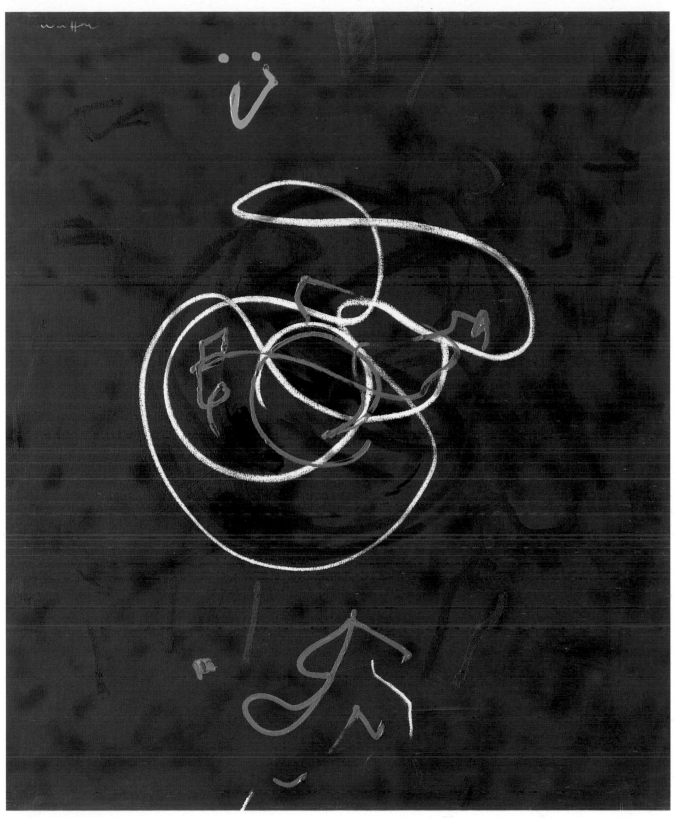

Poems of Lines, 1987
Oil and acrylic on canvas
50 x 42 in.

Emerson Woelffer

137

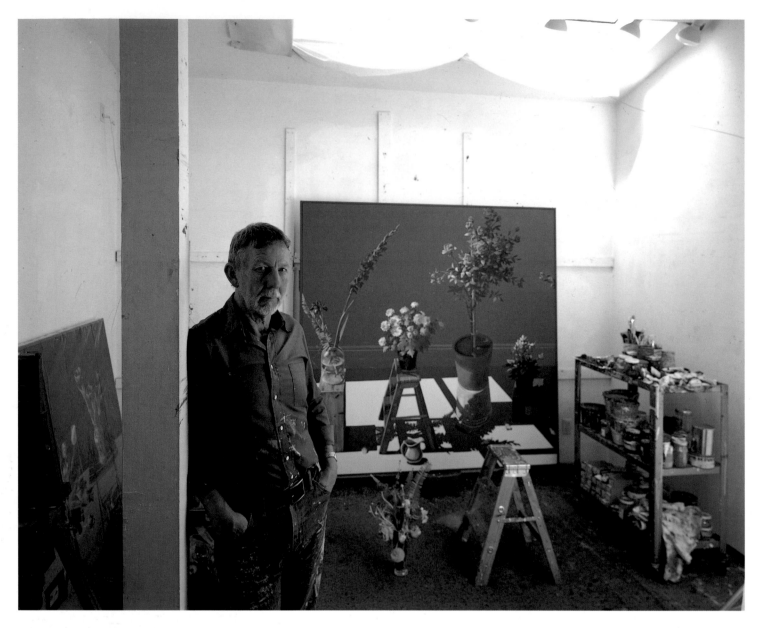

Paul Wonner

My paintings grow out of my admiration for seventeenth-century Dutch still lifes. I always hope for the magic, timelessness, and positive attitude that I find in those paintings.

I never arrange the still life before I begin to paint; the objects are painted one at a time. The still life is imaginary and exists only in the painting.

I begin by loosely brushing in an overall plan, although this changes radically when I begin to work precisely. I feel the painting never really takes hold until something *is* painted as precisely as it will appear in the completed work. Nevertheless, it is often necessary to repaint, move, change, or completely paint out a precisely painted object. It seems important to me that there is this element of surprise and chance.

Recently I've begun to include some figures, birds, or animals, but the process of painting them remains the same.

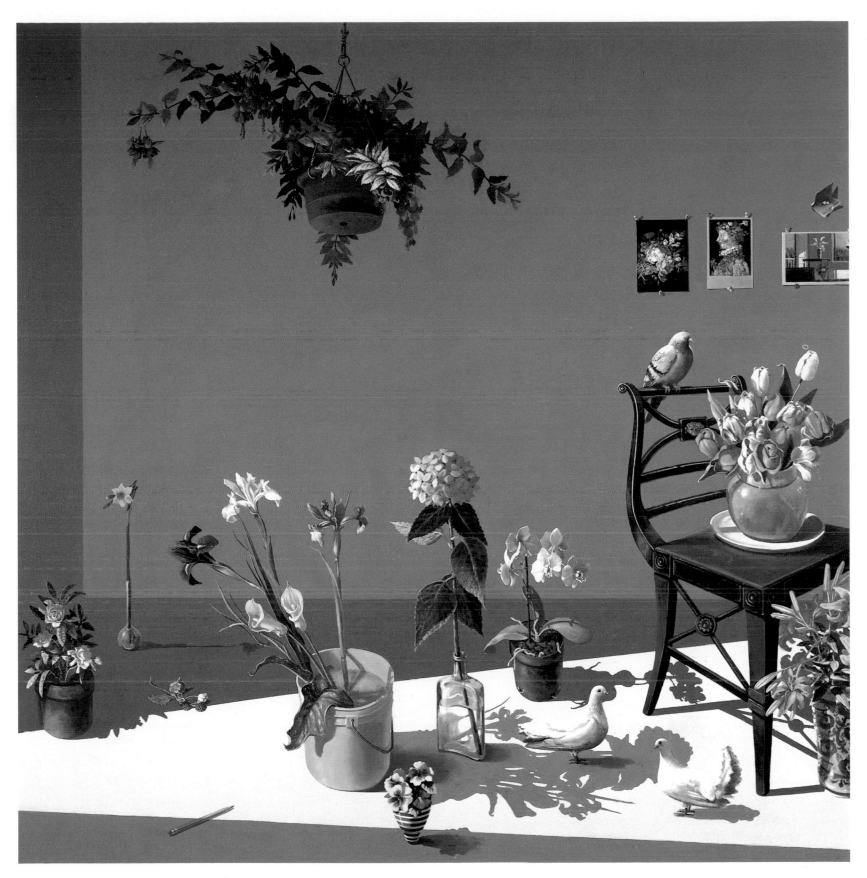

Blue Room with Flowers and Pigeons, 1988
Acrylic on canvas
72 x 72 in.

Paul Wonner

139

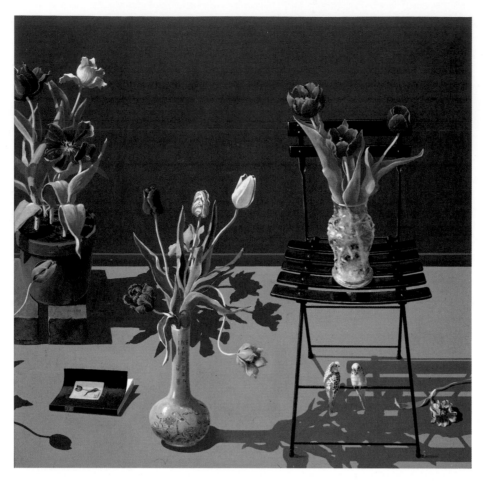

Tulips, 1988
Acrylic on canvas
48 x 48 in.

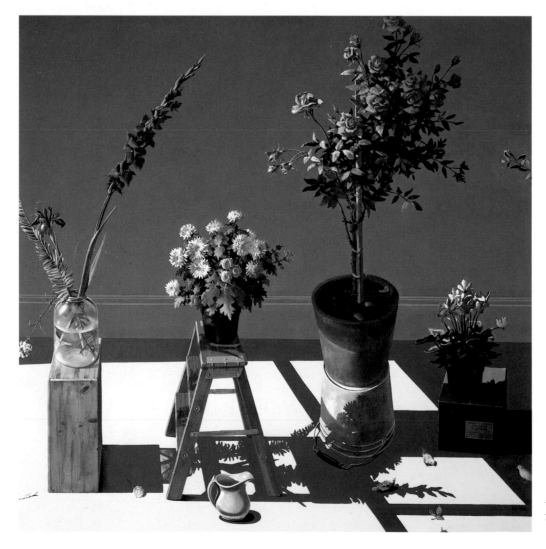

Paul Wonner

Plants and Flowers in a Jar, 1987
Acrylic on canvas
72 x 72 in.

Acknowledgments

The artists and the following collectors, galleries, and museums have generously permitted the reproduction of the works of art illustrated in this book.

Lita Albuquerque

Remembrance I
Collection of Pacific Enterprises
They're coming in swarms by the thousands
Collection of Isabelle Croissant
Transparent Earth
Collection of Ron Weisner

Carlos Almaraz

Buffo's Lament
Southwest Song
Courtesy of Jan Turner Gallery, Los Angeles

Elmer Bischoff

#85
Private collection, San Francisco
#108
Courtesy of John Berggruen Gallery, San Francisco
#109
Collection of Mr. and Mrs. Peter Michael, San Francisco

William Brice

Untitled (1984)
Collection of Gordon F. Hampton, Los Angeles
Untitled (1986)
Courtesy of L. A. Louver, Venice, California
Untitled (1988)
Courtesy of Robert Miller Gallery, New York

Christopher Brown

Confluence
Collection of Thomas J. Klutznick
Lights Along the Silk Route
Collection of Jack and Sandra Guthman
Rivers of the Silk Route
Collection of Jeffrey J. Rhodes

Joan Brown

The Golden Age: The Hummingbird and the Crow
The Golden Age: The Jaguar and the Toucan
Out on a Limb
Courtesy of Frumkin/Adams Gallery, New York

Hans Burkhardt

Gardens Again
Moon over Basel
So Near, So Far
Courtesy of Jack Rutberg Fine Arts, Inc., Los Angeles

Robert Colescott

Desire for Power—Power for Desire
Courtesy of Phyllis Kind Gallery, New York
Hard Hats
Collection of Judy and Howard A. Tullman
Pygmalion
Collection of Mary Grace and Charles H. Carpenter, Jr.

Roy De Forest

Aboriginal Prospectus
Honolulu Advertiser Collection
Canis Prospectus
Collection of Raymond Zakroff, Bala Cynwyd, Pennsylvania
Untitled (1988)
Courtesy of Fuller Gross Gallery, San Francisco

Richard Diebenkorn

Ocean Park #130
Private collection
Ocean Park #132
California collector
Ocean Park #133
Collection of Phil Schrager, Omaha, Nebraska

Llyn Foulkes

Blind Faith
Courtesy of Asher Faure, Los Angeles
From the Top O Topanga
Collection of Mollie R. and William T. Cannady, Houston
That Old Black Magic
Kent Fine Art, New York

Sam Francis

Affective Tension
Collection of Signet Bank/Maryland
Evergreen Licks
Collection of Mr. and Mrs. Arthur L. Boroff

Charles Garabedian

Archipelago of Time
Courtesy of L. A. Louver, Venice, California
The Passing of Montezuma
Courtesy of Hirschl and Adler Modern, New York
Ulysses
Courtesy of L. A. Louver, Venice, California

Rupert Garcia

Magritte Remembered
Private collection, San Francisco
Manet-Fire
Private collection, Los Angeles
Ominous Omen
Courtesy of Iannetti-Lanzone Gallery, San Francisco; Saxon-Lee Gallery, Los Angeles; CDS Gallery, New York

Jill Giegerich

Untitled (1986)
Collection Lannan Foundation
Untitled (1988)
Collection of the Eli Broad Family Foundation

Roger Herman

Bungalow
Untitled 10
Untitled 12
Courtesy of Ace Gallery, Los Angeles
Yellow Auditorium
Collection of Joan and Fred Nicholas

Robert Hudson

Art Felt Swoop
Private collection
Chair
Courtesy of Frumkin/Adams Gallery, New York
Out of the Blue
San Francisco Museum of Modern Art, purchased with the aid of
the Byron Meyer Fund, 81.57.A-D
Untitled (1980–81)
Rene and Veronica di Rosa, Napa, California

Oliver Jackson

Untitled (7.29.86)
Private collection
Untitled (1.5.88)
Private collection
Untitled (5.8.86)
Untitled (7.20.87)
Courtesy of Iannetti-Lanzone Gallery, San Francisco; Eve
Mannes Gallery, Atlanta; Liz Harris Gallery, Boston

Jess

Hermit Tarot
Mort and Marge
"Signd and Resignd," Salvage VII
Courtesy of Odyssia Skouras, New York

Craig Kauffman

Untitled (1987)
Untitled (1987)
Untitled (1988)
Courtesy of Asher Faure, Los Angeles

Helen Lundeberg

Night Flying In
Courtesy of Tobey C. Moss Gallery, Los Angeles
Earth Shadow Rising
Tom Boles Collection, courtesy of Tobey C. Moss Gallery, Los
Angeles

Ed Moses

Blue Trac
Untitled (1986)
Untitled (1987)
Courtesy of L. A. Louver, Venice, California

Lee Mullican

Break Awake
View of Red City
Picasso-Hide-Seek
Courtesy of Herbert Palmer Gallery, Los Angeles

Nathan Oliveira

Model I
Collection of Lydia and Douglas Shorenstein, San Francisco
Painter II
Collection of Mrs. Elaine McKeon, Hillsborough, California
Wing III
Private collection, Sausalito, California

Gordon Onslow Ford

Finding the Child
Collection of Sam Francis

Frank Romero

Highway 64
Collection of Nicholas May
Still Life with Blue Car
Collection of Martin and Deborah Hale

Edward Ruscha

A Girl I Walked All Over
Collection of the Israel Museum, Jerusalem
Inferno
Collection of Mr. and Mrs. Eric Schwartz
You and Your Neighbors
Collection of Paola Escaraga, New York

Raymond Saunders

Celeste Age 5 Invited Me To Tea
Still Life Mixed In With Other Voices
Courtesy of Stephen Wirtz Gallery, San Francisco
Layers of Being
Private collection

Alexis Smith

Mercury
Collection of James and Linda Burrows
Rock of Ages
Collection of the Capital Group, Inc.
Running on Empty
Gift of The Eli Broad Family Foundation, Permanent Collection
of the High Museum of Art, Atlanta, 1988.46
Same Old Paradise
Courtesy of Margo Leavin Gallery, Los Angeles

Mark Tansey

The Bricoleur's Daughter
Collection of Emily Fisher Landau
Mont Sainte-Victoire
Courtesy of Thomas Ammann, Zurich
Secret of the Sphinx (Homage to Elihu Vedder)
Collection of Robert M. Kaye

Masami Teraoka

AIDS Series/Oiran and Kite
AIDS Series/Samurai Twist
Courtesy of Space Gallery, Los Angeles
AIDS Series/Tattooed Woman and Flying Saucers
Courtesy of Iannetti-Lanzone Gallery, San Francisco
AIDS Series/Oiran and Mirror
Courtesy of Schmidt-Dean Gallery, Philadelphia

Wayne Thiebaud

City Police Car
Private collection, New York
Diagonal Ridge
Private collection
Two Gallon Cans
Private collection

Joyce Treiman

Joker, Me, and Geometry
Collection of Mr. and Mrs. L. Freiman, Memphis
The Last Parade
The Metropolitan Museum of Art, New York, acquired 1989
Witness
Collection of ARA Services, Inc., Philadelphia

Paul Wonner

Blue Room with Flowers and Pigeons
Tulips
Courtesy of John Berggruen Gallery, San Francisco
Plants and Flowers in a Jar
Collection of Mr. and Mrs. R. Crosby Kemper, Kansas City

For more information about the artists presented in this book, contact their galleries or representatives; a partial list follows.

Lita Albuquerque
Works Gallery, Long Beach, California

Peter Alexander
James Corcoran Gallery, Santa Monica, California

Carlos Almaraz
Jan Turner Gallery, Los Angeles

Billy Al Bengston
James Corcoran Gallery, Santa Monica, California

Elmer Bischoff
John Berggruen Gallery, San Francisco

William Brice
L. A. Louver, Venice, California
Robert Miller Gallery, New York

Christopher Brown
Gallery Paule Anglim, San Francisco

Joan Brown
Frumkin/Adams Gallery, New York
Fuller Gross Gallery, San Francisco

Hans Burkhardt
Jack Rutberg Fine Arts, Inc., Los Angeles

Robert Colescott
Phyllis Kind Gallery, New York

Mary Corse
Oil & Steel Gallery, Long Island City, New York

Roy De Forest
Fuller Gross Gallery, San Francisco

Richard Diebenkorn
M. Knoedler & Co., New York

Llyn Foulkes
Asher Faure, Los Angeles

Sam Francis
Andre Emmerich Gallery, New York

Charles Garabedian
L. A. Louver, Venice, California

Rupert Garcia
Anne Kohs & Associates, San Francisco
Iannetti-Lanzone Gallery, San Francisco

Jill Giegerich
Margo Leavin Gallery, Los Angeles

Joe Goode
James Corcoran Gallery, Santa Monica, California

Roger Herman
Ace Gallery, Los Angeles

David Hockney
L. A. Louver, Venice, California

Robert Hudson
Frumkin/Adams Gallery, New York

Oliver Jackson
Anne Kohs & Associates, San Francisco
Iannetti-Lanzone Gallery, San Francisco

Richard Jackson
Rosamund Felsen Gallery, Los Angeles

Jess
Odyssia Skouras, New York

Craig Kauffman
Asher Faure, Los Angeles

Helen Lundeberg
Tobey C. Moss Gallery, Los Angeles

Ed Moses
L. A. Louver, Venice, California

Lee Mullican
Herbert Palmer Gallery, Los Angeles

Nathan Oliveira
John Berggruen Gallery, San Francisco

Gordon Onslow Ford
Herbert Palmer Gallery, Los Angeles

Frank Romero
Robert Berman, Santa Monica, California

Edward Ruscha
Leo Castelli Gallery, New York
James Corcoran Gallery, Santa Monica, California

Raymond Saunders
Stephen Wirtz Gallery, San Francisco

Alexis Smith
Margo Leavin Gallery, Los Angeles

Mark Tansey
Curt Marcus Gallery, New York

Masami Teraoka
Anne Kohs & Associates, San Francisco
Space Gallery, Los Angeles

Wayne Thiebaud
Allan Stone Gallery, New York

Joyce Treiman
Fairweather-Hardin Gallery, Chicago
Schmidt-Bingham Gallery, New York
Tortue Gallery, Santa Monica, California

Emerson Woelffer
David Stuart Galleries, Los Angeles
Wenger Gallery, Los Angeles

Paul Wonner
John Berggruen Gallery, San Francisco